IMAGES
of America

CHICAGO'S 1933–34 WORLD'S FAIR
A CENTURY OF PROGESS

Discard

Discard

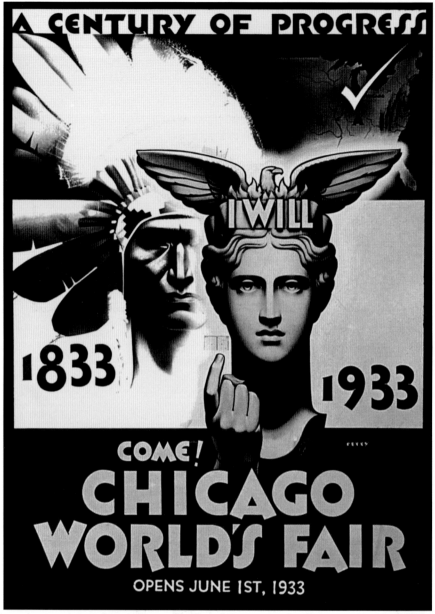

A CENTURY OF PROGRESS

I WILL

1833 1933

COME!
CHICAGO
WORLD'S FAIR
OPENS JUNE 1ST, 1933

The fair organizers created many posters to draw attention to the Century of Progress Exposition. This one drew upon several key moments in Chicago's history, including its founding in 1833 and the extremely successful World's Columbian Exposition of 1893. The figure with "I Will" on her headdress was created for that fair by Charles Holloway, who described her as a mixture of Helen of Troy and Dame Liberty and who signified Chicago's "can do" attitude.

ON THE COVER: The Travel and Transport Building was just one of the unusual structures built for the fair. Instead of traditional large interior columns to support the roof, it used steel cables on the exterior, which provided for previously unimagined large amounts of display space. Many new building techniques and electrical systems were pioneered at the fair.

IMAGES
of America

CHICAGO'S 1933–34
WORLD'S FAIR
A CENTURY OF PROGESS

Bill Cotter

ARCADIA
PUBLISHING

Copyright © 2015 by Bill Cotter
ISBN 978-1-4671-1368-7

Published by Arcadia Publishing
Charleston, South Carolina

Printed in the United States of America

Library of Congress Control Number: 2014949519

For all general information, please contact Arcadia Publishing:
Telephone 843-853-2070
Fax 843-853-0044
E-mail sales@arcadiapublishing.com
For customer service and orders:
Toll-Free 1-888-313-2665

Visit us on the Internet at www.arcadiapublishing.com

To Carol.

R0443164457

CONTENTS

Acknowledgments 6

Introduction 7

1. The North End 9

2. The North Lagoon 21

3. The South Lagoon 35

4. The Center of the Fair 57

5. The South End 83

6. The 1934 Fair 97

7. The Fair at Night 119

ACKNOWLEDGMENTS

Each time I start out to write a book, I know I will have to rely on others for help; this book was no exception. My friends and fellow world's fair fans at www.worldsfaircommunity.org were helpful, as always, in digging out information on the fair or in helping identify some of the more obscure photographs. My thanks also go out to Maggie Bullwinkel and her team at Arcadia Publishing; their help and encouragement in bringing the story of the fair to you is greatly appreciated. I also had the welcomed assistance of Lisa Schrenk, associate professor of architecture and art history at Norwich University in Vermont. Lisa has written extensively about the fair, and her encyclopedic knowledge and suggestions were invaluable.

I am also deeply indebted to my wife, Carol. Besides allowing me to fill the garage with pictures of world's fairs, she has helped me get past writer's block and been understanding when the rush is on to meet a deadline. She also was a tremendous help in the proofreading and editing of the manuscript. Without her assistance and encouragement, this book would not exist.

Unless otherwise noted, all images are from the author's collection.

INTRODUCTION

I was first introduced to the wonders of world's fairs when my aunt visited Expo 58 in Belgium. She treated the family to the inevitable slide show and home movies, and as soon as I saw the Atomium, I was hooked. I spent so much time devouring her guidebook from the fair that she eventually gave it to me—the first item in my world's fair collection.

Over the years, I have been fortunate to attend several of these international extravaganzas and to share some of my photograph collection through these books from Arcadia Publishing. My interests focused mainly on the fairs that I or members of my family had been to, until one day I made a very unexpected acquisition.

A purchase of what was advertised as black-and-white photographs of the Belgian Village at the 1964–1965 New York World's Fair had me stumped. There were all of the buildings I knew so well, but for some reason all the people in the pictures were dressed in much older clothing styles. A little research revealed that the 1964–1965 Belgian Village was, in fact, an almost identical copy of one built decades earlier for the Century of Progress Exposition held in Chicago in 1933.

Intrigued by the similarity of the two villages, I began collecting more items from the 1933 fair, starting with the official guidebook. This only added to my confusion when many of the pictures I was acquiring showed pavilions and shows that were nowhere in the guidebook. Further investigation showed that there had been massive changes to reopen the fair for an originally unplanned second season.

The more I learned about the fair, the more I was intrigued. Like most fairs, this one began with the plan to attract attention and, hopefully, new business to the host city. Unlike other fairs though, this one was not launched with the support of the local government; indeed, at times it seemed like the politicians of Chicago did not want the fair. They had ample reason to feel this way, as most fairs run a sizeable deficit and leave the citizens responsible for paying off the debts. Looking back at the nation's financial situation in those years makes their initial reluctance seem quite prudent.

Luckily, the leaders of the nascent fair did not take no for an answer, and instead plunged headlong into the formidable task of designing, financing, building, and operating the fair. They faced many obstacles along the way, but by amply demonstrating Chicago's motto of "I Will," they found some innovative solutions to the challenges. For example, when funding was running low and money was needed to keep the effort alive, they turned to the public with a fundraising appeal. Thousands of average citizens stepped up with $5 contributions, which not only paid the bills, but also garnered attention from the investment community.

When the first season of the fair failed to attract the crowds that had been forecast, the leaders refused to accept that the fair had failed and lost money. Instead, in another unprecedented move, they encouraged more investors to join in for a second season, one that found major sections of the original season demolished and replaced with even more amazing shows. The daring gamble paid off, and the fair eventually turned a profit—another rarity among fairs.

This was the fair I wanted to show in this book. Rather than using publicity photos prepared by the fair or its many concessionaires, I chose to use amateur images taken by people who had gone to the fair to be entertained, educated, and amazed. My belief is that photographs like these show the items of most interest to the average visitor. Some areas of the fair, like many of the midway shows, were of little interest, and thus rarely photographed. Other sections were a completely new experience and were happily documented in these photographic souvenirs.

It was common at the time to have the name of the fair over-printed on photographs developed at or near the fair; photographs in this book showing such titles are all amateur images and not part of the photograph collections sold at the fair.

I read one article that referred to the 1933–1934 fair as "the last black-and-white" fair. Kodachrome was introduced in 1935, so all we have from this fair are monochrome images or hand-tinted postcards and prints. Even in black-and-white images though, the fair looks to have been a truly amazing event. I dare you to look at the Sky-Ride, for example, and not be impressed by what awaited the lucky visitors who experienced the fair in person.

One final word: the fair has been called by many names over the years. The official name was A Century of Progress International Exposition, but it was commonly called the Chicago World's Fair in the newspapers of the time. I generally have used the shorter version.

—Bill Cotter
www.worldsfairphotos.com
August 2014

The 1933–1934 Chicago World's Fair
A Century of Progress Exposition

May 27, 1933–November 1, 1933
May 26, 1934–October 31, 1934

One

THE NORTH END

The 1933 Chicago World's Fair came into being when a group of business leaders began exploring ways to celebrate the city's upcoming centennial in 1933. One of the first ideas they considered was a world's fair, for Chicago had been home to the immensely popular World's Columbian Exposition in 1893, an event that drew in more than 29 million visitors. Governmental officials initially rejected the plan, but the group forged on, promising to build the fair without any tax money or government subsidies. On December 13, 1927, they received approval to move forward with what was then called the Chicago Second World's Fair Centennial Celebration.

Later formally named A Century of Progress International Exposition, the fair was launched during an economic boom, but soon ran into problems as the world lurched into the Great Depression. While some parts of the original plan had to be scaled back or canceled, the fair's leaders saw the Depression as an opportunity of sorts, for there was a large skilled workforce in desperate need of jobs. The fair quickly became one of the largest employers in the area, making it quite popular with local politicians, businesses, and even the general public. When the fair asked for supporters to invest $5 each to help fund the exposition, a total of 118,773 people rose to the challenge. The funds raised were a welcome infusion of cash, but even more importantly, the effort showed naysayers that the fair was gaining strength and momentum.

Additional investors joined in through a series of bond sales, fulfilling the promise that the fair would be built without government expense. This was an unparalleled development in the history of world's fairs, as was the fact that the fair actually repaid all its investors and generated a sizeable profit.

The fair opened its gates on May 27, 1933. Although initial plans called for a closing date of November 1, 1933, as events unfolded those plans changed dramatically, as detailed in chapter six.

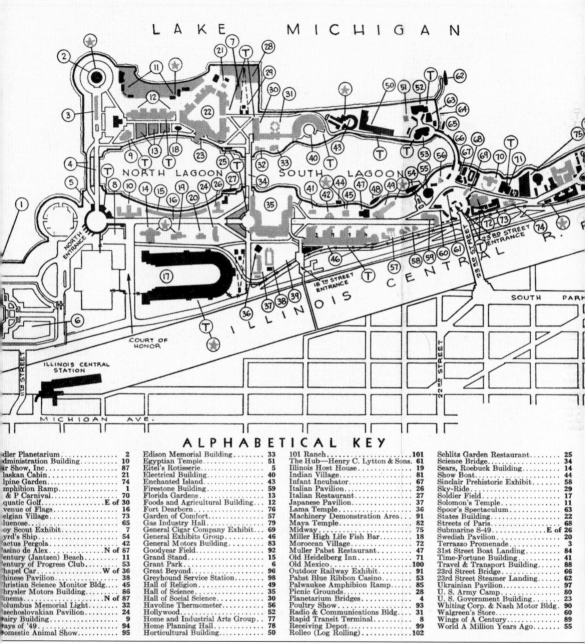

ALPHABETICAL KEY

dler Planetarium	2	Edison Memorial Building	33	101 Ranch	101	Schlitz Garden Restaurant	25
dministration Building	10	Egyptian Temple	51	The Hub—Henry C. Lytton & Sons	61	Science Bridge	34
r Show, Inc.	87	Eitel's Rotisserie	5	Illinois Host House	19	Sears, Roebuck Building	14
laskan Cabin	21	Electrical Building	40	Indian Village	81	Show Boat	44
lpine Garden	74	Enchanted Island	43	Infant Incubator	67	Sinclair Prehistoric Exhibit	58
mphibion Ramp	1	Firestone Building	59	Italian Pavilion	26	Sky-Ride	29
& P Carnival	70	Florida Gardens	13	Italian Restaurant	27	Soldier Field	17
quatic Golf	E of 30	Foods and Agricultural Building	12	Japanese Pavilion	37	Solomon's Temple	11
venue of Flags	16	Fort Dearborn	76	Lama Temple	36	Spoor's Spectaculum	63
elgian Village	73	Garden of Comfort	57	Machinery Demonstration Area	91	States Building	22
luenose	65	Gas Industry Hall	79	Maya Temple	82	Streets of Paris	68
oy Scout Exhibit	7	General Cigar Company Exhibit	69	Midway	75	Submarine S-49	E of 26
yrd's Ship	54	General Exhibits Group	46	Miller High Life Fish Bar	18	Swedish Pavilion	20
asino de Alex	N of 87	General Motors Building	83	Moroccan Village	72	Terrazzo Promenade	3
entury (Jantzen) Beach	11	Goodyear Field	92	Muller Pabst Restaurant	47	31st Street Boat Landing	84
entury of Progress Club	53	Grand Stand	15	Old Heidelberg Inn	71	Time-Fortune Building	41
hapel Car	W of 36	Grant Park	6	Old Mexico	100	Travel & Transport Building	88
hinese Pavilion	38	Great Beyond	96	Outdoor Railway Exhibit	91	23rd Street Bridge	66
hristian Science Monitor Bldg	45	Greyhound Service Station	98	Pabst Blue Ribbon Casino	53	23rd Street Steamer Landing	62
hrysler Motors Building	86	Hall of Religion	49	Palwaukee Amphibion Ramp	85	Ukrainian Pavilion	97
inema	N of 87	Hall of Science	35	Picnic Grounds	28	U. S. Army Camp	80
olumbus Memorial Light	32	Hall of Social Science	30	Planetarium Bridges	4	U. S. Government Building	23
zechoslovakian Pavilion	24	Havoline Thermometer	56	Poultry Show	93	Whiting Corp. & Nash Motor Bldg	90
airy Building	9	Hollywood	52	Radio & Communications Bldg	31	Walgreen's Store	60
ays of '49	94	Home and Industrial Arts Group	77	Rapid Transit Terminal	8	Wings of A Century	89
omestic Animal Show	95	Home Planning Hall	78	Receiving Depot	99	World A Million Years Ago	55
		Horticultural Building	50	Rolleo (Log Rolling)	102		

The map, from the 1933 edition of the fair's official guidebook, gives an indication of the scale and complexity of the fair. The 427-acre site was built on reclaimed land along the shore of Lake Michigan, and many of the pavilions were clustered around a man-made lagoon. Bisected by a pedestrian bridge, the lagoon was split into the North Lagoon and South Lagoon during the fair. Unlike most other world's fairs, the Century of Progress exhibition did not feature clearly defined thematic zones. As a result, the site was a hodge-podge of different types of pavilions gloriously

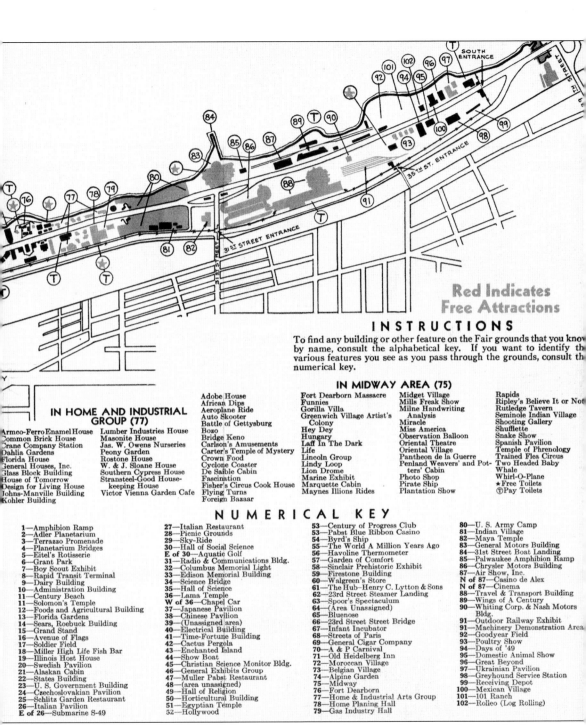

SOUTH ENTRANCE

35TH ST. ENTRANCE

31ST STREET ENTRANCE

Red Indicates Free Attractions

INSTRUCTIONS

To find any building or other feature on the Fair grounds that you know by name, consult the alphabetical key. If you want to identify the various features you see as you pass through the grounds, consult the numerical key.

IN HOME AND INDUSTRIAL GROUP (77)

Armco-Ferro Enamel House
Common Brick House
Crane Company Station
Dahlia Gardens
Florida House
General Houses, Inc.
Glass Block Building
House of Tomorrow
Johns-Manville Building
Kohler Building

Lumber Industries House
Masonite House
Jas. W. Owens Nurseries
Peony Garden
Rostone House
W. & J. Sloane House
Southern Cypress House
Stransteel-Good Housekeeping House
Victor Vienna Garden Cafe

IN MIDWAY AREA (75)

Adobe House
African Dips
Aeroplane Ride
Auto Skooter
Battle of Gettysburg
Bozo
Bridge Keno
Carlson's Amusements
Carter's Temple of Mystery
Crown Food
Cyclone Coaster
De Saible Cabin
Fascination
Fisher's Circus Cook House
Flying Turns
Foreign Bazaar

Fort Dearborn Massacre
Funnies
Gorilla Villa
Greenwich Village Artist's Colony
Hey Dey
Hungary
Laff In The Dark
Life
Lincoln Group
Lindy Loop
Lion Drome
Marine Exhibit
Marquette Cabin
Maynes Illions Rides

Midget Village
Mills Freak Show
Milne Handwriting Analysis
Miracle
Miss America
Observation Balloon
Oriental Theatre
Oriental Village
Pantheon de la Guerre
Penland Weavers' and Potters' Cabin
Photo Shop
Pirate Ship
Plantation Show

Rapids
Ripley's Believe It or Not
Rutledge Tavern
Seminole Indian Village
Shooting Gallery
Shufflette
Snake Show
Spanish Pavilion
Temple of Phrenology
Trained Flea Circus
Two Headed Baby Whale
Whirl-O-Plane
★ Free Toilets
Ⓣ Pay Toilets

NUMERICAL KEY

1—Amphibion Ramp
2—Adler Planetarium
3—Terrazzo Promenade
4—Planetarium Bridges
5—Eitel's Rotisserie
6—Grant Park
7—Boy Scout Exhibit
8—Rapid Transit Terminal
9—Dairy Building
10—Administration Building
11—Century Beach
11—Solomon's Temple
12—Foods and Agricultural Building
13—Florida Gardens
14—Sears, Roebuck Building
15—Grand Stand
16—Avenue of Flags
17—Soldier Field
18—Miller High Life Fish Bar
19—Illinois Host House
20—Swedish Pavilion
21—Alaskan Cabin
22—States Building
23—U. S. Government Building
24—Czechoslovakian Pavilion
25—Schlitz Garden Restaurant
26—Italian Pavilion
E of 26—Submarine S-49

27—Italian Restaurant
28—Picnic Grounds
29—Sky-Ride
30—Hall of Social Science
E of 30—Aquatic Golf
31—Radio & Communications Bldg.
32—Columbus Memorial Light
33—Edison Memorial Building
34—Science Bridge
35—Hall of Science
36—Lama Temple
W of 36—Chapel Car
37—Japanese Pavilion
38—Chinese Pavilion
39—(Unassigned area)
40—Electrical Building
41—Time-Fortune Building
42—Cactus Pergola
43—Enchanted Island
44—Show Boat
45—Christian Science Monitor Bldg.
46—General Exhibits Group
47—Muller Pabst Restaurant
48—(area unassigned)
49—Hall of Religion
50—Horticultural Building
51—Egyptian Temple
52—Hollywood

53—Century of Progress Club
53—Pabst Blue Ribbon Casino
54—Byrd's Ship
55—The World A Million Years Ago
56—Havoline Thermometer
57—Garden of Comfort
58—Sinclair Prehistoric Exhibit
59—Firestone Building
60—Walgreen's Store
61—The Hub—Henry C. Lytton & Sons
62—23rd Street Steamer Landing
63—Spoor's Spectaculum
64—(Area Unassigned)
65—Bluenose
66—23rd Street Street Bridge
67—Infant Incubator
68—Streets of Paris
69—General Cigar Company
70—A & P Carnival
71—Old Heidelberg Inn
72—Moroccan Village
73—Belgian Village
74—Alpine Garden
75—Midway
76—Fort Dearborn
77—Home & Industrial Arts Group
78—Home Planing Hall
79—Gas Industry Hall

80—U. S. Army Camp
81—Indian Village
82—Maya Temple
83—General Motors Building
84—31st Street Boat Landing
85—Palwaukee Amphibion Ramp
86—Chrysler Motors Building
87—Air Show, Inc.
N of 87—Casino de Alex
N of 87—Cinema
88—Travel & Transport Building
89—Wings of A Century
90—Whiting Corp. & Nash Motors Bldg.
91—Outdoor Railway Exhibit
91—Machinery Demonstration Area
92—Goodyear Field
93—Poultry Show
94—Days of '49
95—Domestic Animal Show
96—Great Beyond
97—Ukrainian Pavilion
98—Greyhound Service Station
99—Receiving Depot
100—Mexican Village
101—101 Ranch
102—Rolleo (Log Rolling)

intermixed. International and state pavilions were located amongst the science-oriented displays, carnival rides and games were found in several locations, and corporate pavilions were seemingly scattered at random. The design led to massive congestion on some days, particularly on the narrow strip that led from the lagoon area to the southern end of the fair, but the crowds did not seem to mind, with attendance projections surpassed on a regular basis.

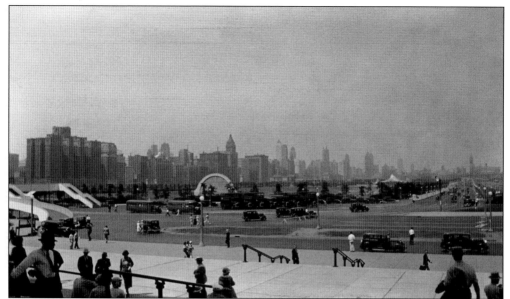

The North Entrance, also called the 12th Street Entrance, was located across from Grant Park. Owning a car was still out of reach for much of the population, so most fairgoers arrived on some form of public transportation, including double-decker buses, taxis, or trains. The ramps of the Illinois Central Railroad station built for the fair can be seen on the left, with Grant Park's original band shell at center.

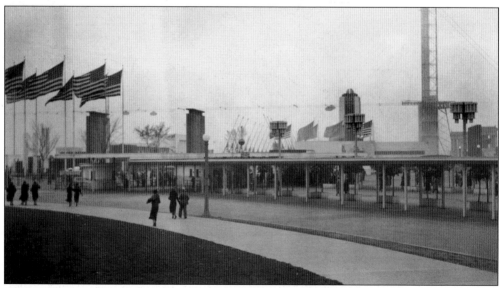

There were six entrance areas in total across the site, with the North Entrance considered to be the main one. Although the area was fairly deserted in this view, there were often long lines waiting to go through the turnstiles. A total of 48,769,227 visitors were recorded over the two seasons of the fair, including free tickets and passes. Adults paid 50¢, and children's admission was 25¢. A 50-visit adult pass was also available for $15.

Visitors entering at the North Entrance came upon the Avenue of Flags, the main route to the Hall of Science, the centerpiece of the fair. Originally planned to showcase flags from the participating nations, it was later decided to use simple colored banners instead. They were felt to be more aesthetically pleasing and did not draw attention to the fact that there were actually very few international exhibitors.

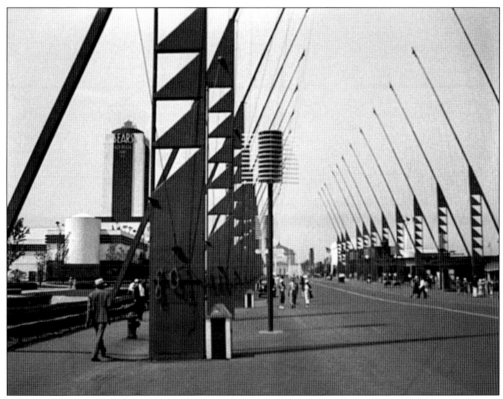

Chicago is not called the "Windy City" without good reason, and the entrance flags often took a beating from the winds coming off Lake Michigan. The crews got pretty quick at furling them up as storms approached, but sometimes they lost the race. Torn and shredded banners had to be replaced frequently, as the entryway did not look very impressive as the "Avenue of Flag Poles."

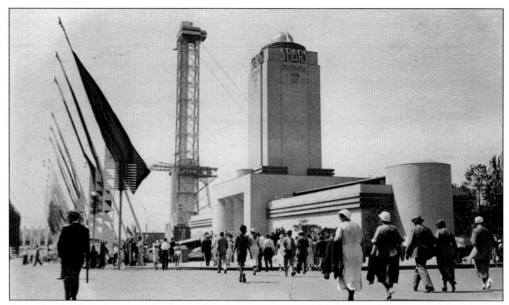

Sears, Roebuck & Company had one of the largest commercial exhibits at the fair. Exhibits showed how Sears had helped establish the department store concept and had grown from a simple mail order catalog to become the nation's largest retailer. The pavilion offered a wide range of services that included an information desk, a shipping center to send souvenirs home, and a fully equipped emergency room that served as the fair's main medical center.

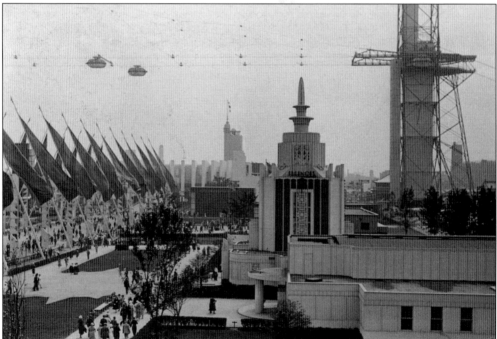

Sears also offered rooms to rest from the noise of the fair and several places to dine. Most guests ate in a large cafeteria inside the windowless building, but a more upscale experience was available in a restaurant near the top of the pavilion's 150-foot tower. From there, diners were treated to views of the fair, Lake Michigan, and, in the distance, the towering buildings of Chicago.

The State of Illinois had a significant presence at the fair. In addition to the $350,000 Illinois Host Pavilion, which featured several exhibits on Abraham Lincoln, there were also state-sponsored exhibits on business, agriculture, and tourism at the Hall of States, the Hall of Science, and the Foods and Agriculture Building. The columned structure behind the pavilion is part of Soldier Field, a sports stadium that opened in 1924.

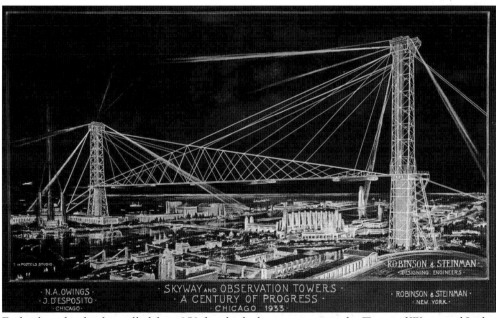

Early plans for the fair called for a 250-foot-high theme structure, the Tower of Water and Light, but the project was canceled in 1932 due to cost and engineering concerns. The fair organizers were forced to reconsider another proposal they had rejected earlier, and with less than a year to go before opening day, they approved the towering Sky-Ride. Five companies banded together to build the $1.4 million system of towers, cables, and two-level "rocket cars."

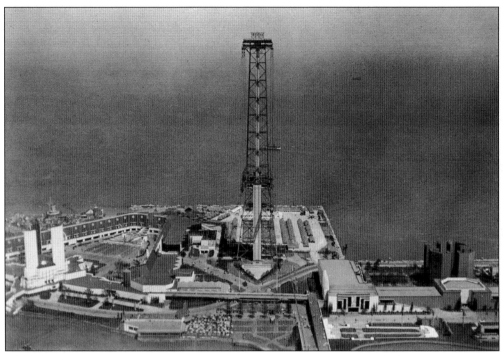

The Sky-Ride featured two massive towers built of 2,000 tons of steel. More than 100 miles of steel wire, fashioned into cables by the company that had built the Brooklyn Bridge, carried a fleet of sightseeing cars high above the waters of the North Lagoon. Although the towers were in place when the fair opened, the ride was not completed until June 16, 1933, due to the delay in beginning construction.

Observation decks near the top of the 628-foot-high towers of the Sky-Ride boasted that they offered views up to 70 miles and of four states. Chicago's reputation as the Windy City undoubtedly made the experience one not to forget. This gentleman, suitably impressed by his visit, wrote, "This is as close to heaven as I'll ever get!" on the back of the photograph.

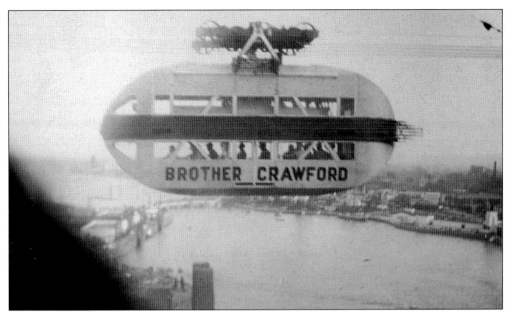

BROTHER CRAWFORD

The two Sky-Ride towers were nicknamed "Amos" and "Andy" after the popular radio series, which had begun on station WMAQ in Chicago. Each of the rocket cars was named after a character from the show, including Amos, Andy, Battle Axe, Kingfish, Madame Queen, and Brother Crawford. The series stars, Freeman Gosden (Amos) and Charles Correll (Andy), opened the ride by breaking a bottle of champagne against the Brother Crawford car.

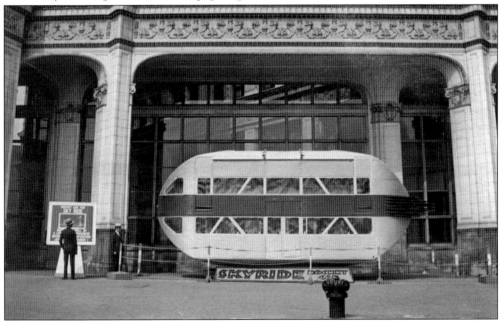

One of the 36-passenger rocket cars was put on display in downtown Chicago to help promote the fair. The Sky-Ride proved to be very popular with visitors, and the towers became the unofficial theme structure of the fair. When they were demolished in 1935, local newspapers lamented that without them towering over the skyline, a hoped-for third season was not to be, and the fair was truly gone forever.

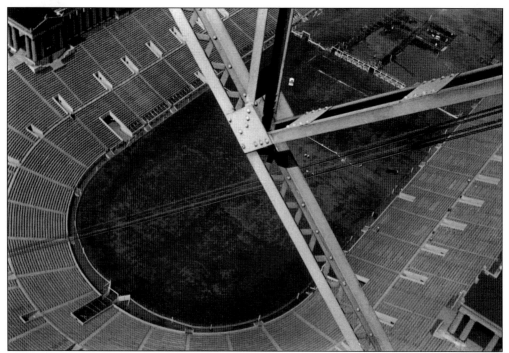

Fair records showed that approximately 12 percent of all visitors paid the extra ticket fee to experience the Sky-Ride. Looking down at Soldier Field far below illustrates why newspapers carried accounts of would-be riders who refused to get off the elevator at the top. Despite the great heights and previously untested technology, the ride operated both seasons without any major problems.

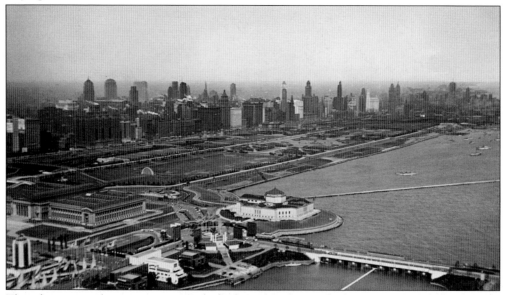

Those brave enough to venture out on the highest observation platforms were rewarded with views previously only obtainable from an airplane or balloon. The Field Museum and Shedd Aquarium, seen here with Grant Park and the towers of Chicago behind them, were not an official part of the fair, but they benefited greatly from the extra visitors who came to town.

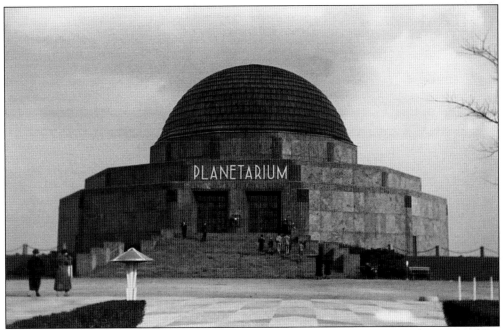

Originally opened in 1932, the Adler Planetarium operated as part of the fair for both seasons. The first planetarium in the United States, it was a gift to the city from Max Adler, a Sears, Roebuck & Company executive. Greatly expanded since the fair, the planetarium is today a vital part of Chicago's Museum Campus, which includes the Shedd Aquarium and the Field Museum.

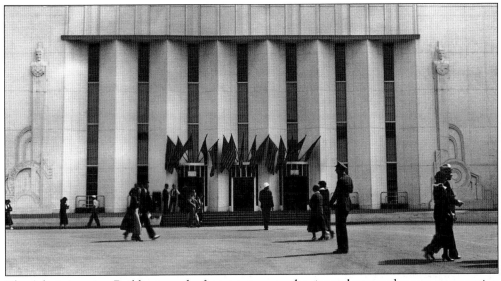

The Administration Building was the first structure on the site and was used to test construction and lighting techniques for the rest of the fair. During the fair, it housed the working offices of the fair corporation, and, for guests, the world's largest photomural, providing an overall look at the site. The building was retained for use by the city's park department after the fair and was finally razed in 1940.

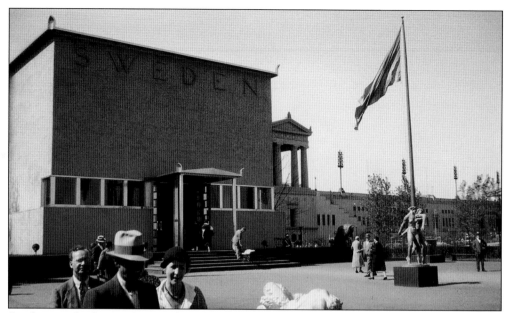

Sweden was the first international pavilion visitors encountered as they traveled down the Avenue of Flags. Brass and marble works by famed Swedish sculptor Carl Milles graced the courtyard outside the main entrance, while inside, displays showcased the nation's art and manufacturing industries. Outside, waitresses in native costumes served up Swedish foods and beverages in an open-air restaurant.

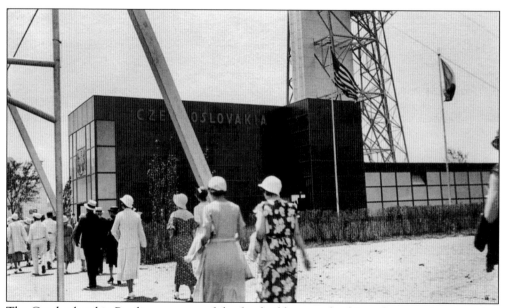

The Czechoslovakia Pavilion was one of the few buildings at the fair to feature a large number of windows, as most exhibitors opted to maximize the display space available inside. There was a large section devoted to tourism and a well-received restaurant, as well as displays focused on the country's glass, woodworking, and jewelry industries. Members of the large Czechoslovakian population in the area also demonstrated native dances and costumes.

Two

THE NORTH LAGOON

Created when Northerly Island was built between 1920 and 1925, the North Lagoon was originally intended to serve as a major theme element for the fair. A large-scale model of the proposed fair was unveiled in 1930 that featured the fair's major pavilion, the Hall of Science, located in the waters of the lagoon. Unfortunately, it was soon discovered that building the pavilion there would be too expensive, and it was eventually built on the shore of the South Lagoon instead.

As a result, the lagoon was left mostly empty and under-utilized. While reasonably scenic during the day, with launches carrying guests across the cooling waters and occasional boat races, the fair's general manager later described it at night as a "dismal and forbidding hole." The buildings on the island were insufficiently illuminated to be clearly seen across the water, so a substantial effort was made to correct that shortcoming for the second year of the fair.

Happily, most visitors were blissfully unaware of what could have been and instead took pleasure in the many pavilions and shows located on both sides of the lagoon. The area was home to the magnificent U.S. Government Building, which housed most of the federal displays, exhibits from 21 states, a lively midway filled with rides and games, and several agriculture-themed exhibits.

After the fair ended, Northerly Island eventually became the site of Meigs Field, an airport that gained fame when it was featured as the main field in Microsoft's popular Flight Simulator program. The area is now being reclaimed as parkland.

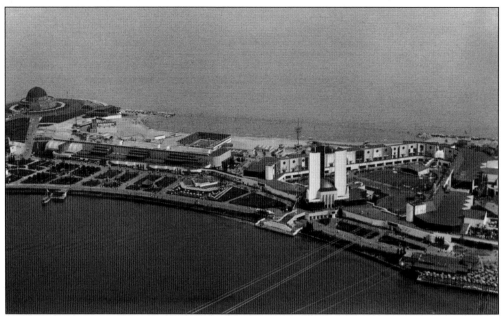

While many of the exhibits in this area were quite popular, there was one spectacular failure. A large section of Northerly Island was devoted to Jantzen's Beach, which offered fairgoers a chance to swim in Lake Michigan. One can only wonder why the fair organizers and the concessionaire thought people would take time out from a day at the fair to go swimming. This area was completely revamped when the fair reopened in 1934.

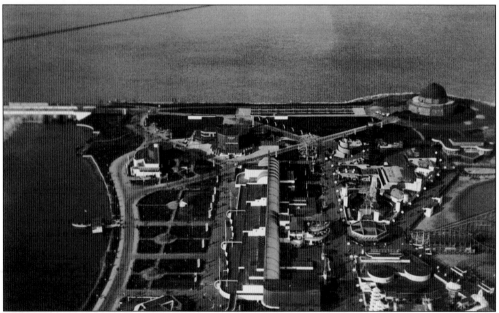

Fortunately, other sections of Northerly Island were better received than the beach. The long building in the center of this view from the Sky-Ride was the Foods and Agriculture Building. The large open areas to its left were the Florida Gardens, with amusement park rides strung along the right side. The Dairy Building can be seen above the gardens, with the Florida Sponge Boat anchored in the lagoon.

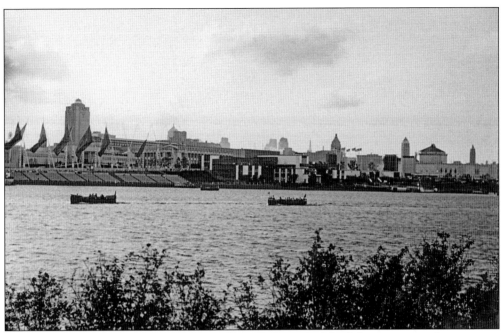

Very little use was made of the grandstand overlooking the North Lagoon; most days just saw passenger launches plying the waters as they ferried guests to and from Northerly Island. The majority of visitors reached the island via a causeway, pedestrian bridge, or Sky-Ride, so the boats were mostly for amusement and relaxation.

The fair organizers did their best to make use of the lagoon, staging a number of boat races and other events in an attempt to liven up the area. Some unusual boats were added, including a replica of a Viking ship, but the area was so large the boats were difficult to see from the grandstand. Improving the use of the lagoon would become an important part of the plans to reopen the fair in 1934.

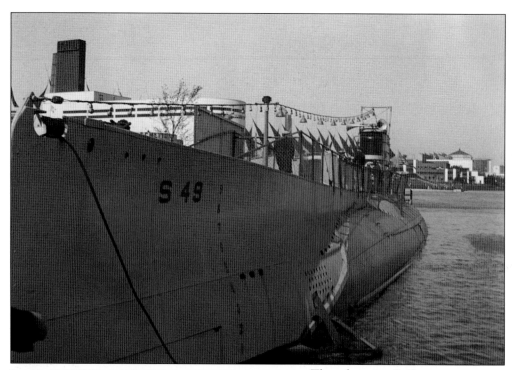

The submarine S-49 was a very unusual exhibit; instead of being a US Navy vessel, it was actually privately owned. Built in 1922 and sold for scrap in 1931, the sub was purchased by F.J. Chrestensen, who charged 25¢ for a tour. Afraid that it might be mistaken for a German U-boat and sunk, he sold the sub back to the Navy at the onset of World War II.

The Florida Sponge Boat featured a family of Greek divers from Tarpon Springs, Florida, who sailed their small boat across the Gulf of Mexico and up the Mississippi and Illinois Rivers to get to the fair. For a small fee, visitors could watch a hard-hat diver descend to the bottom of the lagoon for a simulated sponge harvest. Sadly, the divers lost money on the trip and picked up a case of malaria on the way home.

The U.S. Government Building, seen across the lagoon from the Avenue of Flags, was designed with a 40-foot-wide landing so dignitaries could arrive in style for their tours of the building. However, it was soon found that it was far easier to travel there by land and not have to deal with the vagaries of traveling by boat, especially in the brisk breezes that often come off the lake.

The federal government spent $1 million on a number of displays at the fair, with most of them in the impressive U.S. Government Building. Three 150-foot-high towers that symbolized the three branches of government—legislative, judicial, and executive—circled a 70-foot rotunda. The building was quite large, measuring 620 feet long and 300 feet deep, but exhibits from a number of agencies were also located elsewhere throughout the fair.

While prior fairs featured individual buildings for each state, the Chicago organizers hoped to attract a larger number of participants by grouping them into one large States Building, which was located next to the U.S. Government Building. Allotting equally sized sections allowed the poorer states to participate along with the wealthier ones. At the center was the Court of States, which hosted performances by state groups that traveled to the fair.

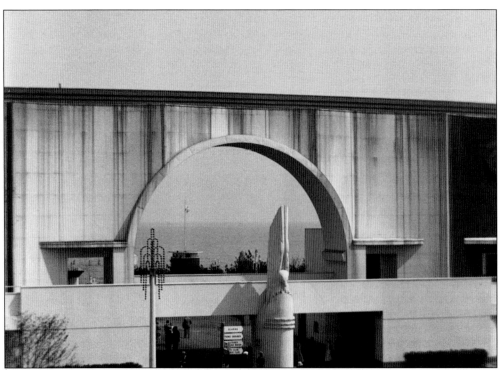

Soaring arches in the States Building allowed cooling breezes in from the lake. Initial plans called for space for 42 exhibitors, but the design was scaled back to a maximum of 32 to make space for one of the Sky-Ride towers. Several states canceled their contracts and pulled out when new governments were elected in 1932, and others dropped out as the nation's economy worsened. A total of 21 states and Puerto Rico exhibited at the fair in 1933.

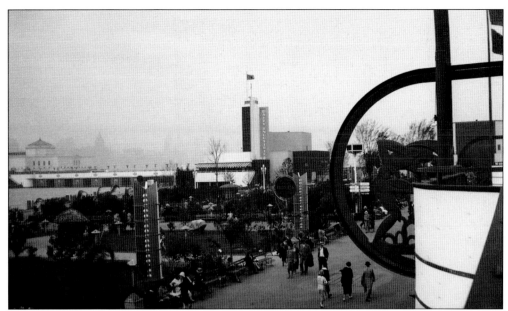

Florida chose a completely different venue for its exhibit, creating a three-acre garden to showcase its important citrus industry and other flora. A grove of orange trees was carefully shipped to the fair, with each orange hand wrapped to help it survive the journey. It is quite likely these are the only orange trees to have blossomed and grown fruit outdoors in Chicago. The gardens also recreated a section of the Everglades.

"Dairy products build superior people" was the theme of the 15,000-square-foot Dairy Building. An eight-minute film traced the history of the dairy industry, followed by examples of modern processing methods. Other displays touted the value of dairy products as part of a healthy diet and explained how cows converted their diet of grass into milk. The pavilion also featured a restaurant that focused on dairy products.

At 95,155 square feet, the Foods and Agriculture Building was one of the largest exhibit halls at the fair. Reflecting the fair's Midwestern roots, an entire section of the building, called Farm Equipment Hall, was dedicated to the latest in tractors, harvesters, and other items of interest to the agriculture business.

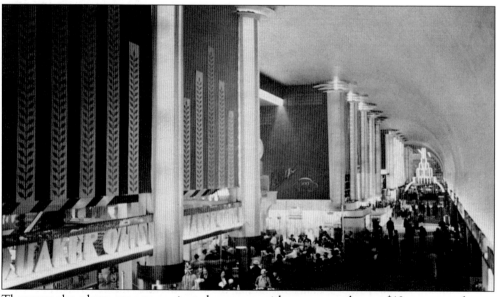

There was also a large consumer-oriented presence, with space rented out at $10 per square foot to a wide variety of exhibitors who showcased their food products. The area was especially popular on special days when free samples were given out. In a fitting tribute to Chicago's reputation as the "meatpacker to the world," a series of displays followed the path of a herd of cattle from the open plains to the meat counter at the local market.

Here, an operator of a roller chair, which could be hired for $1 per hour including someone to push it, rests for a moment in front of the Italy pavilion. This was perhaps the most well received of the fair's international exhibits. Displays included presentations on the nation's many historical sites, as well as recent advances in industry, especially aviation. A fleet of biplanes flew from Italy to salute the fair, which was a major achievement in 1933.

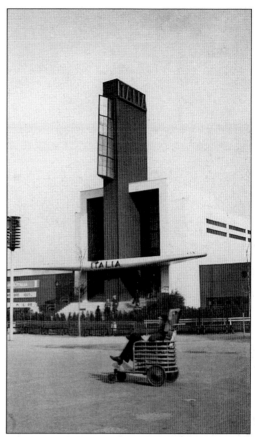

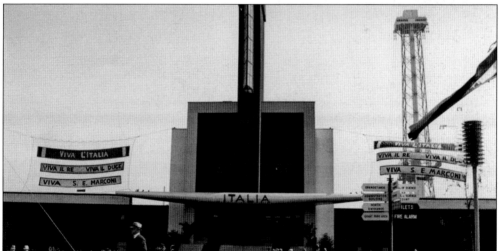

Banners outside the Italy pavilion saluted the nation, the king, inventor Guglielmo Marconi (who visited the fair), and dictator Benito Mussolini. Knowing what was to come in World War II, one can only look in wonder at this entry from the official guidebook for 1933: "The voice of modern Italy, vibrant with the heroic deeds of Fascism, speaks more resoundingly, more intelligently and more forcefully to the World's Fair visitor than that of any foreign nation participating in A Century of Progress."

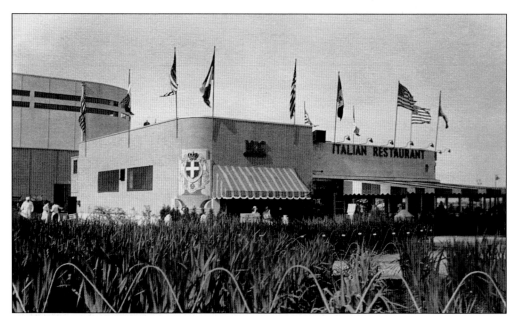

Happily, politics was not an issue for most of the fair and did not affect the very popular Italian Restaurant. A bed of gladiola shows a small portion of the 75,000 square feet of flowers planted to beautify the once barren, man-made plot. More than 1,600 trees and 25,000 shrubs were planted as well, but only after tons of topsoil and peat moss were used to cover the rocks and debris that formed the area.

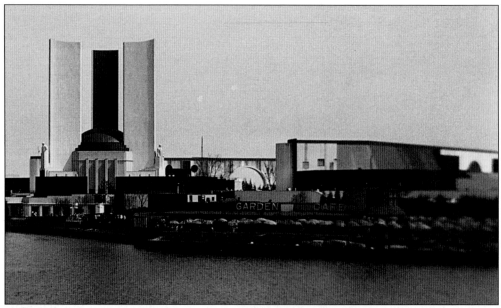

Prohibition was still in effect throughout the 1933 season, but with work well underway to repeal it, the alcohol industry took advantage of the fair to get back into the public eye. Schlitz, Miller, and Pabst, for example, sponsored restaurants, including the Schlitz Garden Café, seen here next to the U.S. Government Building. While most of the fair closed at 10:00 p.m. each evening, the restaurants stayed open until 2:00 a.m. and had popular live bands.

Not everything in the area was intended to be educational; in fact, many of the fair's amusement attractions were located near the North Lagoon in a section called the Beach Midway (not to be confused with the Main Midway, near the center of the site). Although the rides and shows were evidently thought to be so generic that they were not mentioned in the 1933 official guidebook, many of them proved to be quite popular.

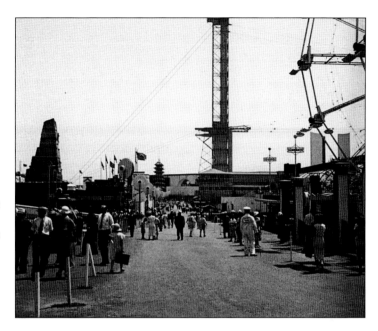

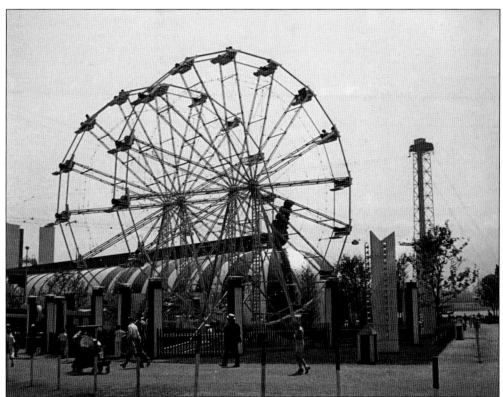

The Ferris wheel was introduced at the earlier Chicago world's fair in 1893, so it was only natural that one would be at this fair as well. In fact, a double Ferris wheel was a prominent part of the Beach Midway. Serving as the entrance symbol to the amusement area, the Giant Ferris Wheels featured two wheels that ran independently of each other.

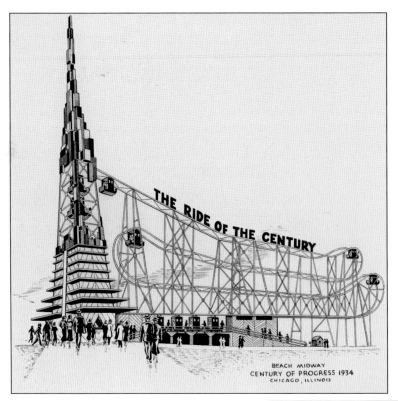

BEACH MIDWAY
CENTURY OF PROGRESS 1934
CHICAGO, ILLINOIS

Many new rides are introduced at world's fairs and stay popular for years to come, so it was not surprising to see some elaborate plans for the 1933 fair. "The Ride of the Century" would have hoisted cars of passengers up a tower and then sent them careening down a track much like an upside-down roller coaster. Unfortunately, the ride never made it past the initial proposal state.

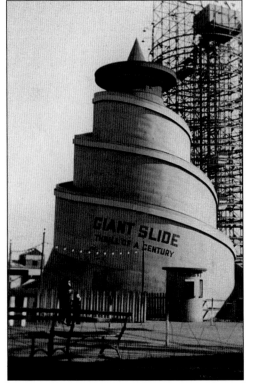

Thrill seekers instead had to settle for the "Thrill of a Century" by riding the Giant Slide. After climbing to the top, riders sat on a burlap sack as they corkscrewed back down to the ground. It is doubtful that many of them felt the ride lived up to its billing. In 1934, the slide was not as heavily hyped and the sign simply read "Conical Slide."

The Tower Dip ride also featured a corkscrew design but was apparently more popular than the Giant Slide. While tickets for the slide were sold for 5¢–10¢, the Tower Dip commanded a premium, with ticket prices of 25¢–40¢. The Tower Dip was the tallest ride in the Beach Midway area.

The Beach Midway also featured several "dark rides," longtime staples of many carnivals and amusement parks. Those too timid to venture inside the Devil's Playground may have taken advantage of the booth next door that advertised "Take Home a Movie of Yourself." A three-minute film of visitors in front of photographs of scenes from the fair was only 25¢.

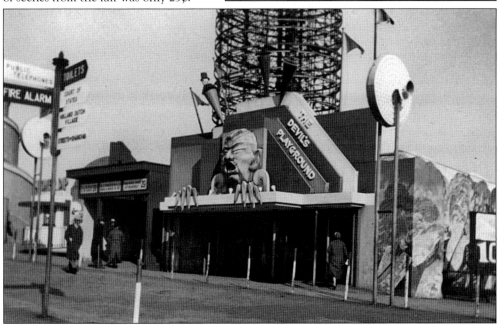

Another carnival perennial, the Guess Your Weight concession, was also featured at the fair. The man in the white pith helmet was one of the fair's policemen. They did not have many problems with the guests—there were only 228 arrests in 1933 despite more than 22 million visitors—but some of the concessionaires were a constant source of trouble, and there were numerous complaints about noise and overly aggressive sales pitches.

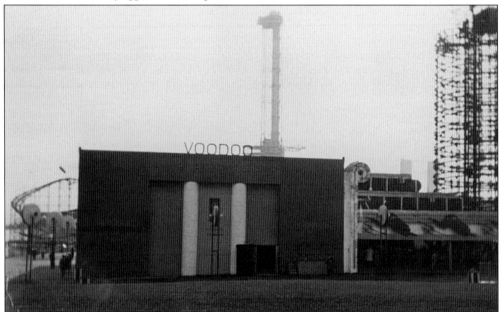

The success of the 1932 film *White Zombie* may have influenced the fair to agree to include this somber looking exhibit that was simply called Voodoo. Guests were invited inside to learn more about the origins and rituals of the religion and to meet a "Goddess of Voodoo"—for a small extra fee, of course. Next to it were booths featuring traditional carnival games of chance.

Three

THE SOUTH LAGOON

While the North Lagoon area had some problems with size and lackluster shows, the fair was much more exciting at the neighboring South Lagoon. Some of the largest and most popular pavilions were located in this section, which ensured a steady stream of visitors. The South Lagoon also offered more in the way of restaurants, a pleasant promenade along the water, a very popular children's amusement area, and, from time to time, tours of ships from visiting navies.

The fair's overall focus on science was well served in this section. The massive Hall of Science, perhaps the most prestigious and popular pavilion of the fair, towered high over the other structures on the mainland side of the lagoon. Across the water, near the southern tip of Northerly Island, the Electrical Building was but one of a series of interesting-looking structures that drew in the crowds.

An early ambitious plan called for a massive structure in the lagoon that would have been the 1933 fair's equivalent of Paris's Eiffel Tower. Designed by prominent architect Ralph Walker, a leading member of the fair's architectural standards committee, the Tower of Water and Light would have been 450 feet tall, with water running down its sloping sides to create a swirling mist effect at the bottom. The Montgomery Ward department store chain agreed to finance the tower, which would have been left in place after the fair, but ever-increasing costs and concerns about the design of the tower led Montgomery Ward to drop out before work actually began. Walker tried to scale the tower back to 250 feet, but to no avail. Some early merchandise featuring artwork of the tower was released, but unfortunately that was as far as the grand plans ever got.

It is interesting to note that China and Japan were located on adjacent plots, even though the two countries were at war with each other. Surprisingly, this generated little attention from the press or the crowds at the fair, but a similar pairing would be unlikely in a fair held today.

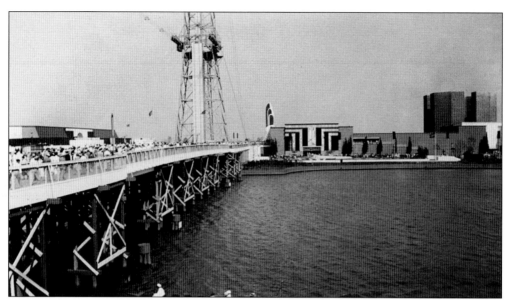

The North and South Lagoons were divided by Science Bridge, which was a major pathway to Northerly Island. The bridge effectively blocked large vessels from the North Lagoon, so most ships were docked in South Lagoon. Others had to be partially disassembled to get under the bridge. After the fair ended, the bridge was removed and the two lagoons became Burnham Harbor, named after Daniel Burnham, who spearheaded the building of Northerly Island.

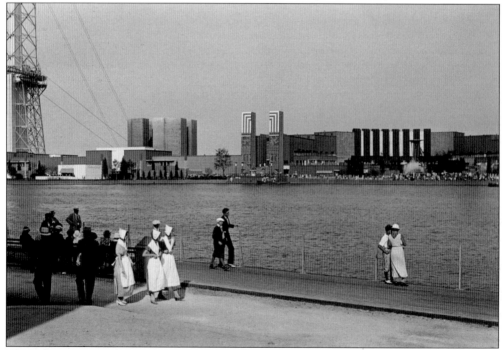

The walkway next to the South Lagoon provided some excellent views of the pavilions on Northerly Island. Here, a group including several women in traditional Dutch costumes is enjoying a stroll along the shore. The Edison Memorial Building, the Hall of Social Science, and the Electrical Building are off in the distance.

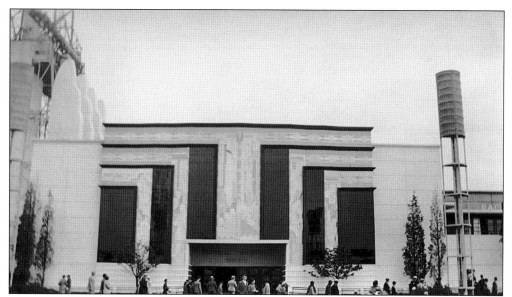

The fair planners had high hopes for the Hall of Social Sciences, exclaiming "Here you will find demonstrated many of the applications man has made of basic science discoveries for his mental stimulation and enjoyment. You will see how he uses the leisure afforded by shortening his working hours through scientific achievements." Unfortunately, corporate sponsors failed to appear due to a lack of promotional opportunities and many of the hoped-for exhibits failed to materialize.

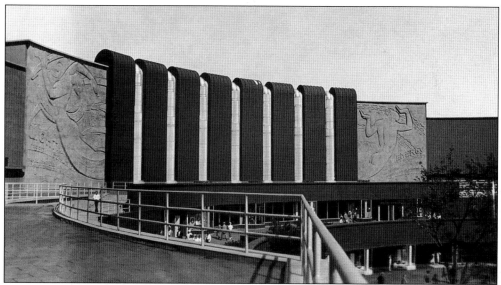

Attracting sponsors was not an issue for the Electrical Building, where 20 companies offered displays of their latest electrical marvels. There were also presentations on the benefits of hydroelectric generating plants, an explanation of the new technology behind neon lights, and of the nation's dependence on a sturdy and reliable power distribution grid. The semi-circular building was designed by Raymond Hood, the architect of Chicago's famous Tribune Tower.

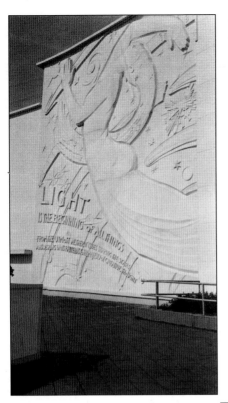

Unlike the earlier 1893 fair, this one had very few sculptures, though there were several at the Electrical Building. Two bas-relief murals by Ulric Henry Ellerhusen were featured on either side of the curving façade. The caption under this mural reads "Light is the beginning of all things, from the utmost aether it issues shaping the stars answering in its patterns to the majesty of creative thought." The other mural celebrated "Energy."

Located in the courtyard of the Electrical Building, the aptly named Electrical Fountain featured pulsating jets of water that were colored by hidden lights. The fountain's 70-foot-high canopy, made of hammered copper, was coated with chromium to reflect the lights and colors, making the display visible for a considerable distance.

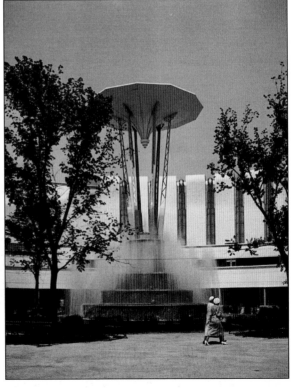

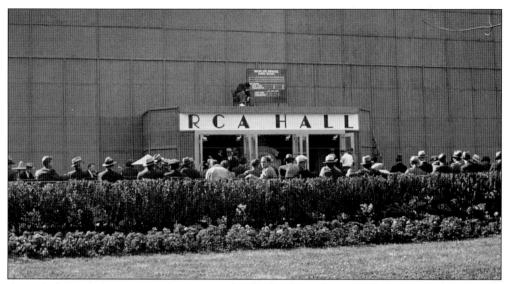

An early form of television was demonstrated at the fair, but radio was still the king of the airwaves. The RCA exhibit was full of the latest radio sets, demonstrations of record manufacturing, and theaters for remote broadcasts. The area was especially popular during the World Series, and crowds eagerly waited for the latest score between the New York Giants and the Washington Senators. The Giants won in five games.

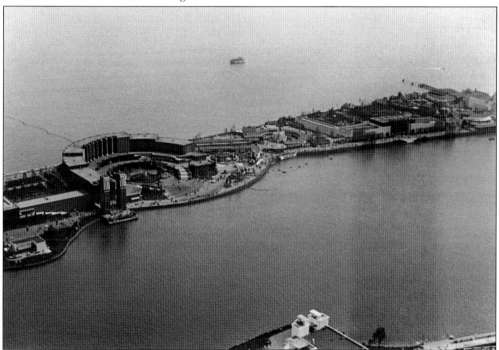

Stretching southward from the curving Electrical Building was the Enchanted Island amusement area, followed by the Horticultural Group, a large collection of indoor and outdoor garden displays, on the far right. There was an entrance fee for the Horticultural Building, which was operated by a concessionaire that exhibited plants from around the world. Several simulated home gardens were on hand to spark visitors' interest in ordering plants for home delivery.

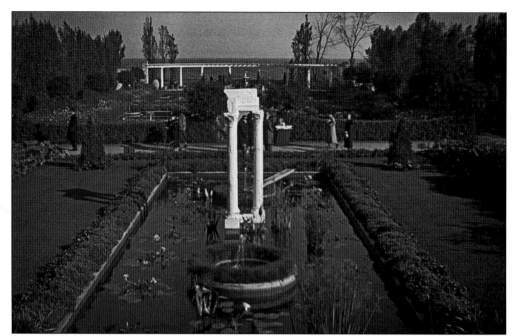

The outdoor gardens, spread across five acres, were popular with visitors. The centerpiece was an elaborate Italianate-themed garden that featured five fountains, towering trees, and marble carvings imported from Florence. Each garden offered a quiet oasis from the noise and commotion of the rest of the fair. They were popular with those with a serious interest in gardening as well as those just out for a leisurely stroll.

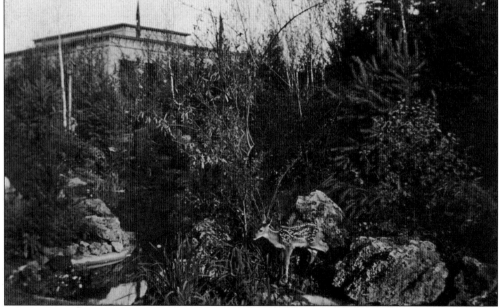

There were also several gardens featuring the flora, and in some cases the fauna, of natural-looking areas such as forests, bogs, and meadows. Tamed deer, geese, swans, and other animals freely roamed the grounds, much to the delight of visiting children and would-be nature photographers. Admission to the gardens was included in the admission price for the Horticulture Building.

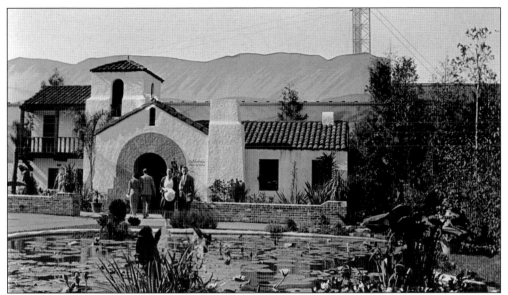

A side wall of the Horticulture Building was used to excellent advantage as a painted mountain backdrop for the California Hacienda. Designed in the traditional Spanish Mission style, the building was surrounded by plants that represented the many different agricultural regions of the Golden State. Beds of flowers from the moister coastal regions were mixed with a wide variety of cacti, while other displays featured wildflowers and plants normally seen in forested areas.

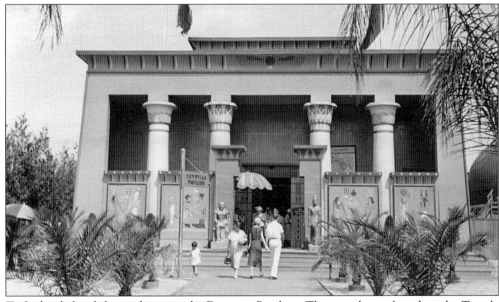

Tucked in behind the gardens was the Egyptian Pavilion. The outside was based on the Temple of Philae; inside was a recreation of the Hypostyle Hall of the Temple of Karnak. There were displays on ancient Egyptian rulers, with a focus on King Tutankhamun, which included both real and replica items from their reigns. The pavilion also included presentations on modern Egypt, particularly the tourism business.

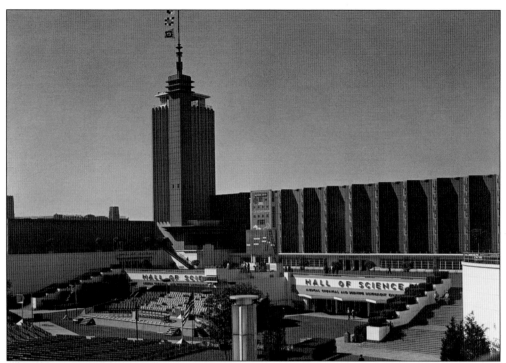

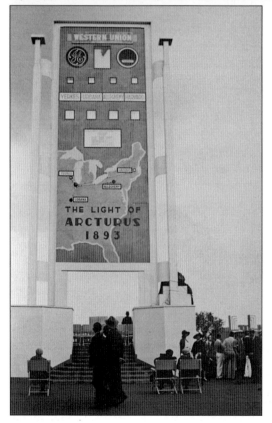

Located on the mainland side of the South Lagoon, the Hall of Science was a major exhibition venue, and in many ways, the heart of the fair. The organizers wanted an overall focus on science for the exposition, citing it as one of the reasons Chicago had become so successful in the 100 years since its founding. A panel of industry and educational experts was formed to select the exhibits in the Hall of Science.

The 1893 Chicago fair was opened with the push of a button that set the machinery in motion, much to the amazement of the watching crowds. For 1933, an elaborate system of photo sensors was used to capture light from the star Arcturus, which had taken since the last fair to finally reach Earth. This board allowed visitors to watch as the signal was relayed between observatories where the light was captured and the fair.

The Hall of Science was a massive structure, with more than 400,000 square feet of display space on an eight-acre plot. The striking structure was the work of Paul Cret, who also designed the University of Texas at Austin's campus. The building was first intended to be a general exhibit hall, but became the Hall of Science when the originally planned tower in the lagoon had to be canceled due to cost.

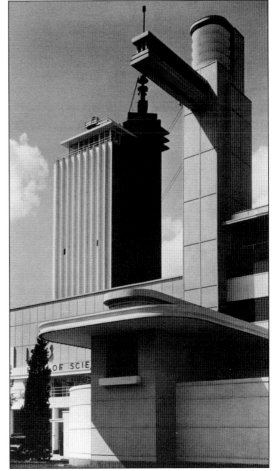

In 1932, parts of the fair site were opened for tours while work was still underway on building the sprawling complex. These tours generated public interest in the upcoming fair, but perhaps more importantly, they were a welcome source of additional funding. The cavernous Hall of Science was one of the first buildings to be completed and is seen here prior to the installation of the exhibits.

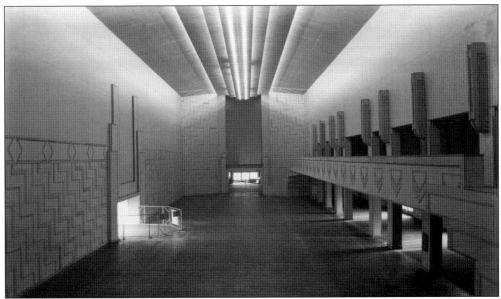

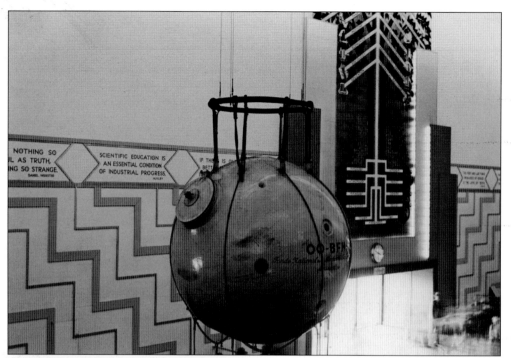

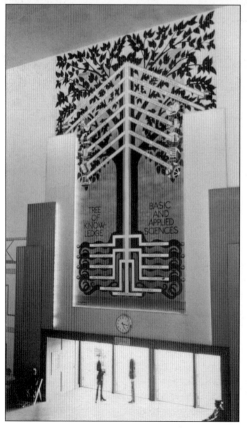

The exhibits inside the Great Hall were quite varied. This sphere was used by balloonist Auguste Piccard to reach a new altitude record of more than 10 miles. Displayed beneath it was the Bathysphere, another spherical vessel, which had carried William Beebe and Otis Barton on a series of record-setting dives off the coast of Bermuda. The walls of the display area were lined with quotations from famous scientists.

The *Tree of Knowledge* was one of the last works by famed muralist John Warner Norton, who died in early 1934. The 40-foot painting featured 11 roots depicting the basic sciences, with 14 limbs representing the applied sciences. Four other murals by Norton also graced the walls of the exhibit area.

There were two courtyards at the Hall of Science. The main one, facing the South Lagoon, featured the sculpture *Science Advancing Mankind* by Louise Lentz Woodruff. A large robot, representing science, was seen gently pushing a man and a woman "towards a better future." Woodruff later donated the robot, which had become known as Steelman, to Joliet Central High School, her former school, which uses Steelman as its mascot to this day.

The second courtyard faced the Avenue of Flags. Four sculptured panels by John Storrs depicted physics, chemistry, natural science, and mechanical science in human form. The centerpiece, also by Storrs, was a 21-foot-high plaster statue titled *Knowledge Combating Ignorance*, where ignorance was depicted as a serpent that was impeding the progress of man, representing knowledge, by wrapping itself around his leg.

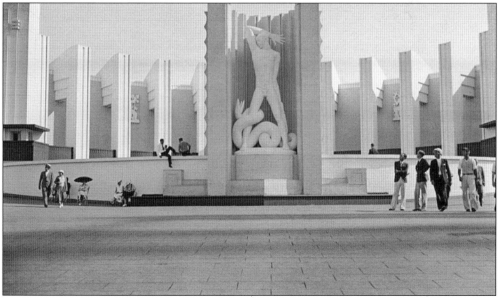

This view of the Hall of Science shows how large the structure was. Parts of the building had a third story, but it was not used due to concerns about evacuation in case of a fire. The Greyhound tram in the foreground was part of a 60-tram fleet that shuttled 90 riders at a time across the site. Seen here during the 1932 preview period, it does not yet sport its world's fair paint scheme.

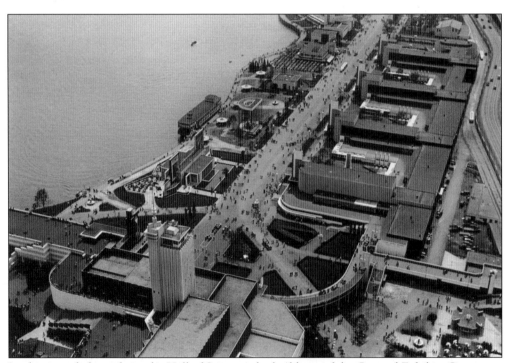

Looking south from above the Hall of Science, the buildings of the General Exhibits Group ran along the perimeter of the fair site. The buildings were designed to offer a maximum amount of interior configurations to suit the needs of individual exhibitors, but were intended to look as uniform as possible on the outside so as to not be visually jarring. As a result, there was little exterior signage.

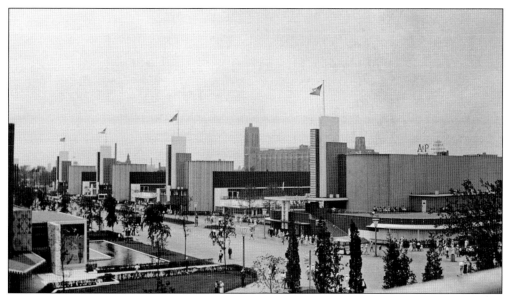

The General Exhibits Group provided a setting for exhibitors who did not logically fit into the fair's other themed areas. There were five buildings in the group, which were divided into mineral industries and industrial engineering; graphic arts and paper products; furniture, office equipment, and sporting goods; jewelry and cosmetics; and textiles. Many of the exhibits produced samples of the company's products on assembly lines right at the fair.

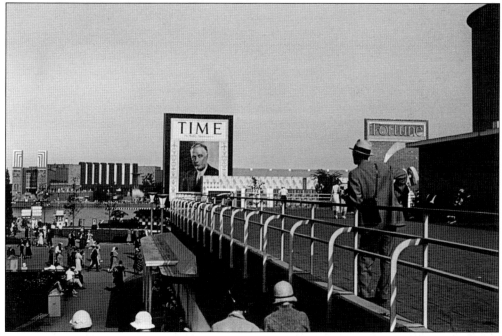

A man relaxes as he looks from the General Exhibits Group towards the Time-Fortune pavilion. There, a large reading room, with the world's largest magazine rack, offered fairgoers a chance to sit and catch their breath before heading out to see more of the fair. The giant magazine covers were mock-ups and not copies of actual issues; this kept them from looking dated during the course of the fair.

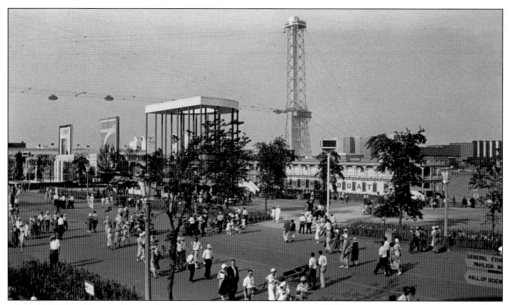

The Cactus Pergola consisted of tall poles supporting a roof high above a fountain designed to look like a group of cacti. Next to it was the *Cotton Blossom*, a replica of a Mississippi riverboat, with a most unusual show indeed. There were no dancing girls or games of fortune; instead, it featured a display of medieval torture devices. After the fair, it was raided several times as an illegal gambling den.

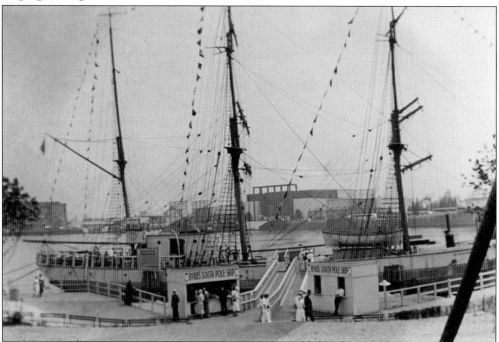

Another ship at the fair had a far more distinguished pedigree. Billed as "Byrd's South Pole Ship," the *City of New York* featured several members of the crew who had traveled to the South Pole with Adm. Richard Byrd on his record-breaking trip to Antarctica. The *City of New York* was one of the exhibits open during the 1932 preview.

Many of the world's religions exhibited in the Hall of Religion. Ancient artifacts were displayed next to modern texts that explained the tenets of the exhibitors. A stage provided a venue for choirs and other performers to entertain. Religious groups traveled from near and far across the country to participate. A non-denominational chapel offered a place for quiet thought and contemplation.

The Christian Science Monitor Building, the only religion-sponsored exhibit outside the Hall of Religion, followed stories through the many steps needed prior to appearing in the *Christian Science Monitor* newspaper. Other exhibits explained how the advertising and sales departments functioned and showed the papers' distribution network. A reading room was available to those interested in the literature or in just wanting to enjoy the air conditioning, a rare luxury in 1933.

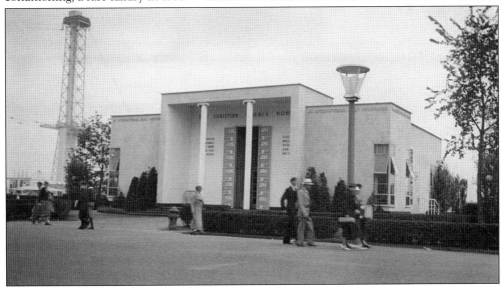

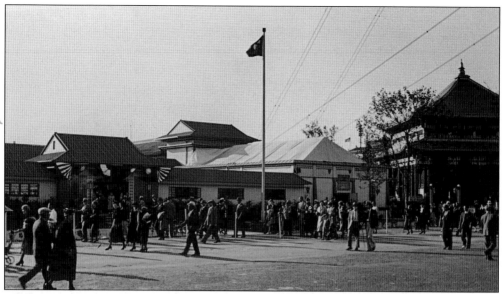

China was one of several international participants in the South Lagoon area. Although a contract was signed in 1931, delays in finalizing the design and sponsorship meant that construction did not actually begin until early 1933. There were several buildings in the China section, and getting them ready in time for the opening of the fair required a substantial amount of international coordination.

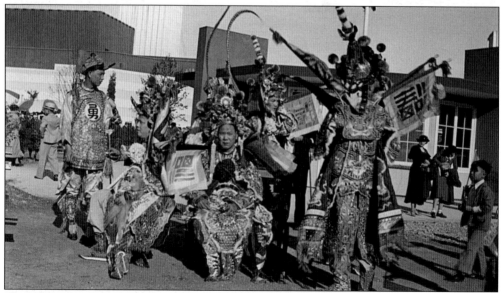

China brought a large contingent of dancers, musicians, artists, and other performers to appear at the fair. The dance troupes were particularly well received, possibly more for their elaborate costumes than for their actual dancing. In the days before television made it easy to see culture from distant lands, events such as this would have seemed quite exotic.

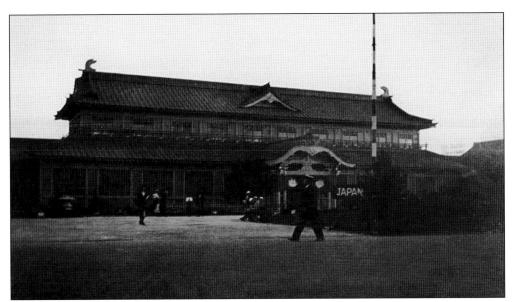

Built by native craftsmen using traditional tools, the Japan pavilion received only token funding from the Japanese government. Most of the expenses were borne by an industrial consortium formed for the fair. In addition to the expected displays of silk, tea, and other agricultural products, there was also a separate, smaller building showcasing Japanese plans for Manchuria, which it had invaded in 1931. A traditional teahouse provided some less confrontational moments.

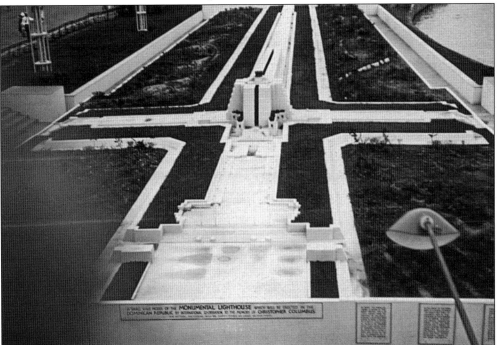

The Dominican Republic exhibit showcased a model of a giant lighthouse to be built in honor of Christopher Columbus. Although the design was selected in 1932, a series of problems befell the project, and construction did not begin in earnest until 1986. Finally finished in 1992, it cost $70 million—far more than the entire cost of the fair.

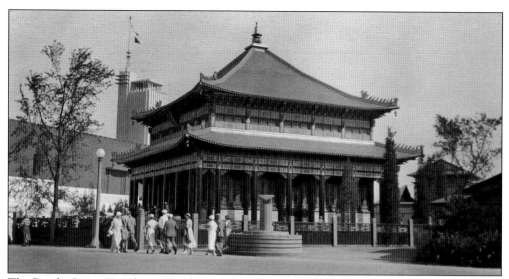

The Bendix Lama Temple recreated the Golden Pavilion of Jehol in China. Each of the 28,000 pieces in the original was carefully duplicated in a project funded by Vincent Bendix, one of the fair's trustees. The roof alone required more than $25,000 worth of 23-karat gold leaf. Bendix commissioned the project in 1929 without a site in mind, and later agreed to exhibit it at the fair when he joined its board.

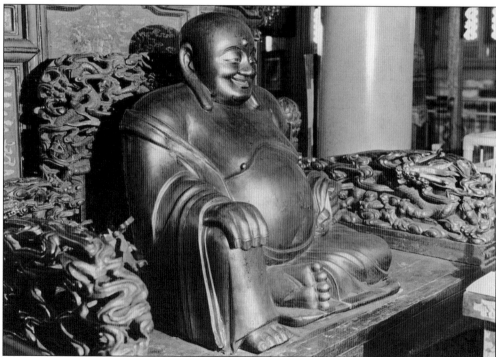

The temple included a replica of the Laughing Buddha, which was carved from a solid block of wood and covered in gilt and lacquer. The temple was one of the few structures left on the site when the fair was demolished. It stayed in Chicago until it was moved for the 1939–1940 New York World's Fair. The temple has been stored in Sweden since 1984, and plans to re-assemble it have been blocked due to protests by the Chinese government.

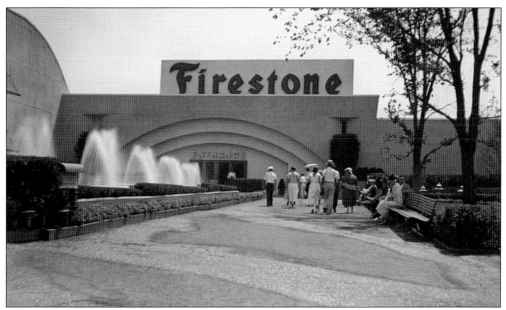

The Firestone exhibit was a study in contrast. Inside, huge presses and steaming cauldrons of molten rubber demonstrated how tires were made by creating them in front of the crowd; outside, a fountain patterned after the Alcazar Gardens in Seville, Spain, entertained guests with changing patterns that were synchronized with music. The Singing Fountain proved to be a favorite place to rest for many weary fairgoers.

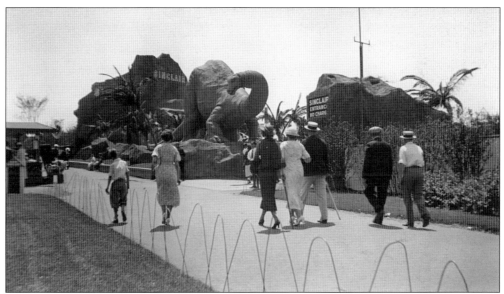

The Sinclair Oil Corporation has long associated its products with dinosaurs, based on the assumption that these giant beasts were the basis for the fossil fuels used to produce gasoline. In 1932, it registered the brontosaurus as the company trademark, noting that people seemed to like it more than other dinosaurs. It was only fitting that a giant brontosaurus graced the entry to Sinclair's exhibit at the fair.

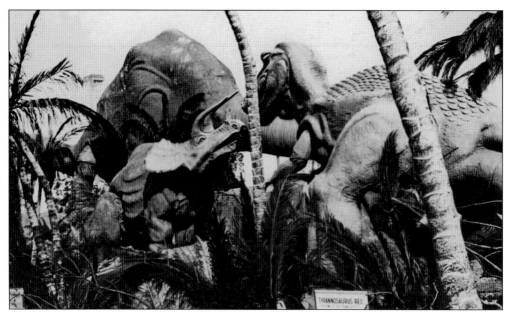

There were seven dinosaurs in the Sinclair exhibit. Built with assistance from a Hollywood special effects crew and natural history scientists, the creatures amazed audiences as they moved their heads, swung their tails, and lunged at each other in mock battles. Hidden speakers provided the roar of the beasts and other prehistoric sounds. This is believed to be the first outdoor recreation of dinosaurs in their natural environment.

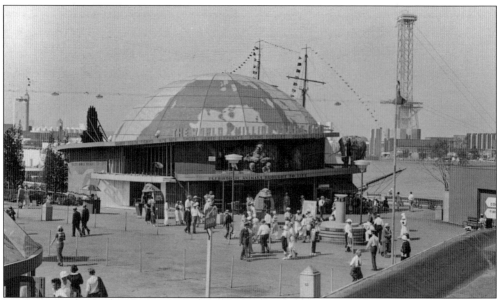

Dinosaurs were also on display at the World a Million Years Ago exhibit. A moving platform carried visitors past six dioramas of ancient life, then into the main hall, where replicas were seen in motion. A sign outside the pavilion listed some of the displays: saber tooth tigers, ape-men, shovel-jawed elephants, flying reptiles, and ground sloths. The show was a financial failure, in large part because the Sinclair dinosaurs were free.

The fair had a special entertainment area designed for younger guests. Parents could drop their children at Enchanted Island, where trained nurses were on duty to watch over them, or they could stay to enjoy the rides and shows together. The five-acre complex also included a restaurant with a menu designed for younger palates.

The staff at Enchanted Island was specially costumed to put their young charges at ease. This turbaned greeter welcomed them as they entered, and guides dressed as wooden soldiers were ready to walk them through the rides and shows. Admission was free for children, but adults were charged 10¢.

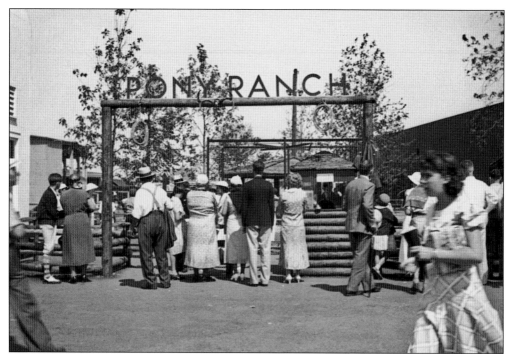

Enchanted Island offered a variety of attractions, including a miniature airplane ride, several fanciful slides, a child-sized maze, a carousel, a pony ride, and more. The very popular Children's Theater showed a steady stream of well-received amateur productions. Other venues, including a marionette show, promised entertainment throughout the day. The area was decorated with characters based on children's stories and toys.

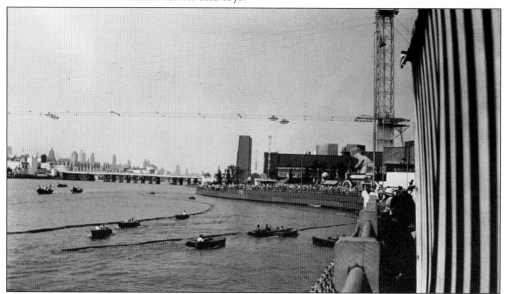

There was also fun out on the lagoon, where would-be captains and admirals could rent small motorboats and cruise through a course denoted by floating lane markers. Because the boats did not run on tracks, there were undoubtedly plenty of collisions and stranded boaters to keep the folks onshore well entertained.

Four

THE CENTER OF THE FAIR

By the time visitors who had entered at the North End of the fairgrounds finally reached the center of the site, they were probably ready to head home to rest their weary feet. Luckily, they could return another day to continue their adventures through the 23rd Street Entrance. The entrance could be reached by train or taxi, but it was also the main entrance for those who had come by private car.

The exhibits waiting inside this gate were quite different than those in the northern or southern sections of the fair. The main change was a much smaller number of pavilions with educational components; the theme for this area was fun, fun, fun. Not very far inside the gate was the fair's main midway, a colorful, if somewhat seedy, collection of carnival games, freak shows, thrill rides, and other concessions. There were also a few displays with more uplifting qualities, but they seem to have been placed there by chance rather than design.

The center of the fair was not without redeeming features, however. There were several "villages," or groups, of themed buildings, and the concept proved to be extremely popular with fairgoers who delighted in touring the replicas of Paris, Belgium, and the Far East. There were also wooden stockades that celebrated historical moments in the history of Chicago and in the life of Abraham Lincoln. Those who would insist a fair has to be educational and look toward the future may have been impressed by the Home and Industrial Group, where new materials and designs for houses were on display. Interestingly, that particular area was one of the most popular sections of the fair.

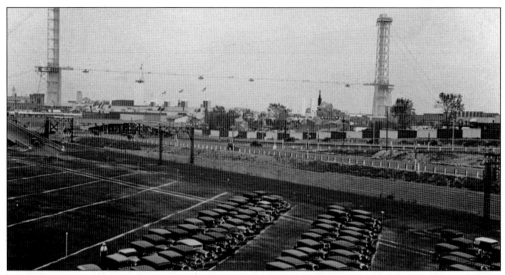

While most visitors arrived using some form of public transportation, many also came by car. A section of land owned by the Illinois Central Railroad that ran parallel to much of the fair site was cleared, and temporary overpasses and ramps were added to speed traffic in and out of the lot. Some publicity articles and postcards claimed it was the world's largest parking lot, with 7,000 spaces.

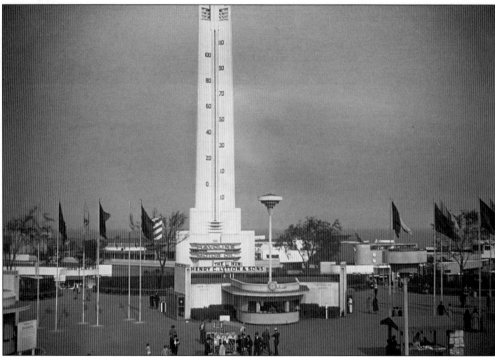

Guests entering at the 23rd Street Entrance were undoubtedly impressed by the 240-foot-tall Havoline Thermometer, which used 10-foot-tall numbers and 3,000 feet of neon tubing in what was billed as the world's largest thermometer. At its base, clothing was available at the Hub, a branch of a department store chain operated by Henry C. Lytton & Sons, and an information booth was provided by the Travelers Aid Society.

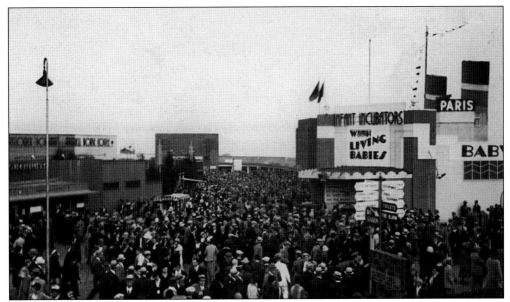

Some sources say the fair was created with an estimate that 60 million paying customers would visit in 1933, though only 22,565,859 actually came. Looking at this scene just past the giant thermometer makes one wonder how the fair could possibly have handled the expected crowds. Not every day was this crowded, of course, but photographs show very few empty days, even when it was raining.

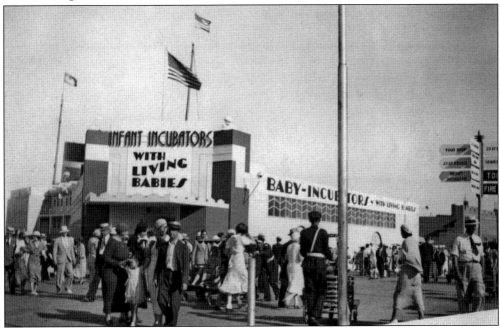

Infant Incubators, one of the more unusual exhibits at the fair, housed up to 25 premature infants who were cared for by a staff of 20 nurses. The medical care, which was supported by an admission fee, was provided for free to the parents. While such a pavilion seems rather bizarre by today's standards, there had been similar exhibits at other fairs, beginning with the Alaska-Yukon-Pacific Exposition in 1909.

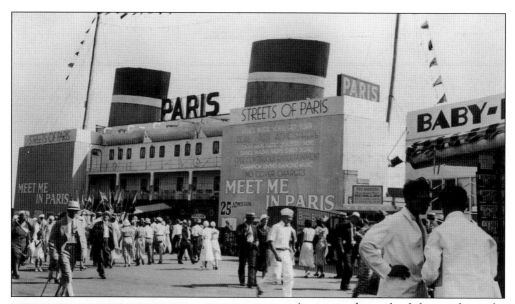

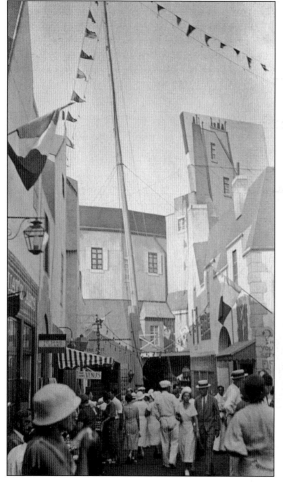

A more traditional exhibit was located right next door to the babies. Streets of Paris featured copies of French restaurants, sidewalk cafés, and shops, as well as strolling gendarmes, mimes, dancers, and other street performers. The façade was designed to look like a trans-Atlantic passenger liner, complete with lifeboats and two rakishly slanted striped funnels. Staying with the theme, visitors paid the 25¢ admission fee at a "Customs Declaration" booth.

After "boarding" the "ship" by walking up a sloping gangway, visitors were greeted by a colorful combination of narrow streets, flags, and signs in French enticing them to visit the many shops and restaurants. The rear sides of the funnels were painted like towering buildings to help continue the illusion of Parisian streets. While most of the exhibits did resemble scenes from Paris, for some reason there were also swim races and diving exhibitions.

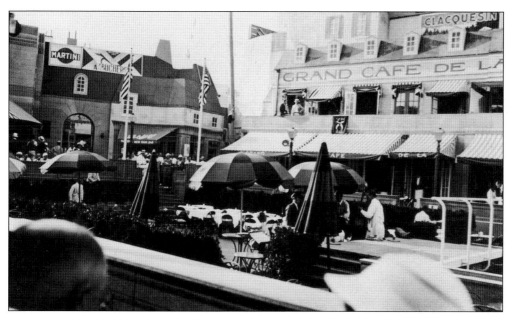

Some of the recreated buildings were fairly accurate copies of real structures in Paris—or at least their lower floors. Introducing a hint of scandal to the fair, one of the big draws was famed fan dancer Sally Rand, as well as other scantily clad women who performed at several peep shows. Streets of Paris proved so popular, raking in $100,000 per day, that almost a dozen other simulated cities were added to the fair for the 1934 season.

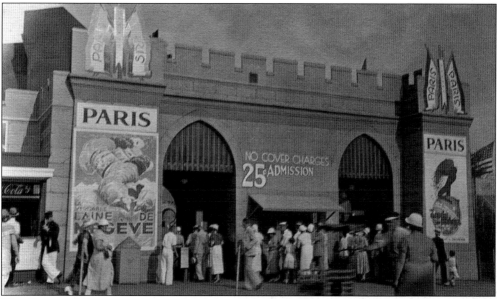

The Streets of Paris was so large that it featured a second, less fanciful entrance. While the attraction was extremely popular with the guests, it proved to be a constant source of irritation for fair officials. Faced with a barrage of complaints and police raids, the fair went through a series of court battles with the concessionaire, sometimes resorting to shutting the venue down when things really got out of hand.

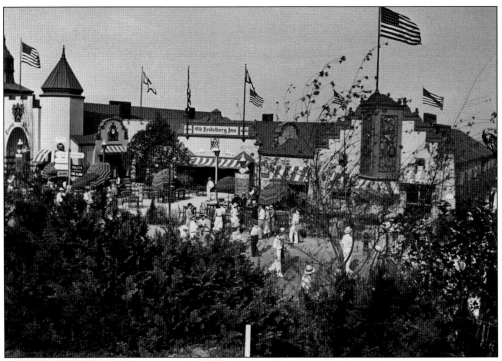

Another recreated slice of Europe was the nearby Old Heidelberg Inn. Based on a restaurant in Heidelberg, Germany, it seated 3,500 guests. The inn was operated by the Eitel brothers, noted Chicago restaurateurs. Originally from Stuttgart, Germany, they ran several successful restaurants that featured German foods and entertainment. After the fair opened, they opened another Old Heidelberg Inn in the Loop district.

The Old Heidelberg Inn was very popular even though it could not serve beer or other alcohol in 1933. In 1934, the Eitel brothers took advantage of the end of Prohibition and the promise of thirsty beer drinkers by adding a new area called the Black Forest. They later operated beer halls at the Texas Centennial Exposition in 1936 and the 1939–1940 New York World's Fair.

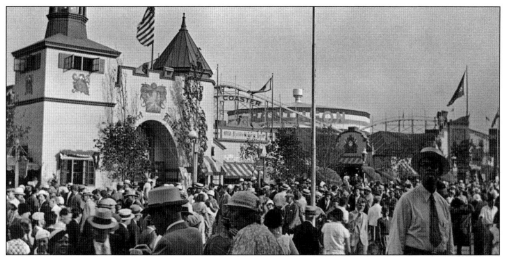

One reason why the Old Heidelberg Inn may have been so popular, even during Prohibition, was its location on the always crowded walkway that connected the South Lagoon area to the rest of the fair. This area was a perpetual traffic jam, with people trying to get from one end of the fair to the other, to and from the 23rd Street Entrance, or into or out of the Midway area in the background.

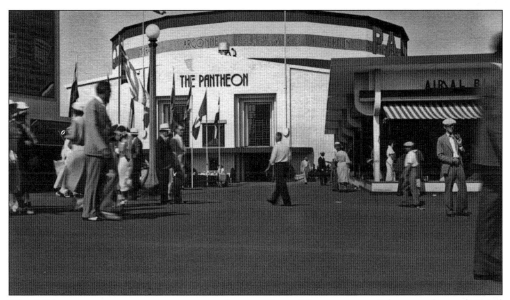

The Midway was a strange assortment of concessions. Most were straight out of a traditional county fair, featuring freak shows and games of chance, but some, surprisingly, had an educational element. One of the largest of these housed the *Panthéon de la Guerre*, the world's largest painting. More than 6,000 life-sized figures were depicted in scenes from famous battles of World War I.

The Hollywood exhibit invited guests to come in and watch movies and radio shows being made, for a fee, of course. It is doubtful that any of the stars on the marquee ever appeared at the exhibit. Instead, the main attraction was watching simulated filming, including a stunt show, and taking pictures of family or friends on replicas of Hollywood sets.

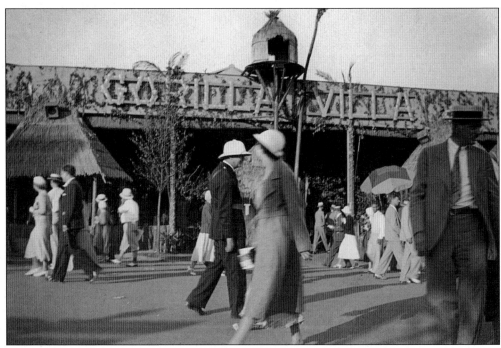

Among the many offbeat attractions in the Midway area was the Gorilla Villa, which featured two gorillas and ten chimpanzees. One of the star performers was a large gorilla named Massa, who later became famous for being the oldest gorilla in captivity. During the fair, he entertained crowds by performing household chores, such as dusting and sweeping the pavilion.

Many of the attractions in the fair's Midway area could not be part of a fair today due to changes in public attitudes. The Africa Dip attraction, for example, offered a chance to drop a black performer into a tank of water by tossing balls at a target. All of the other shows paled in comparison, though, with the Midget Village, which proclaimed itself as the "Home of the Smallest People on the Planet."

After paying a 25¢ admission fee, visitors could tour the 9,000-square-foot Midget Village, which was a scaled-down version of a Bavarian walled city. A reported 60–115 Lilliputian residents operated a variety of shops and restaurants in its 45 buildings and posed for pictures as they strolled through the grounds. The Midget Village proved to be one of the most profitable concessions of the 1933 season, and the venue was expanded for 1934.

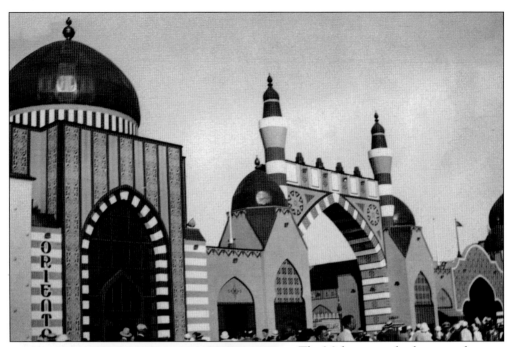

The Midway was also home to the Oriental Village. Colorful towers beckoned with the allure of sights, sounds, and foods from a diverse list of countries. Much of the area was actually based on Egyptian motifs; the main attraction was the Oasis, an upscale restaurant designed to simulate a lively rest stop along a desert caravan route.

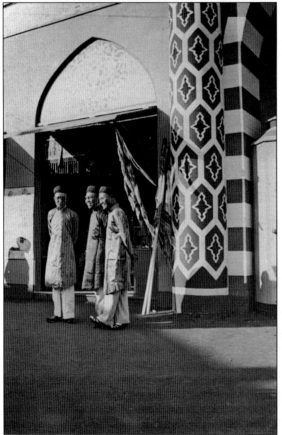

Small shops offering a wide range of products dotted the streets of the Oriental Village. Most of the Asian themes in the area came from these shops, which featured imported goods and handcrafted items. Some newspapers touted the area as looking like a bazaar out of *The Arabian Nights*, complete with beggars. It is hard to see how that last element would have attracted repeat visitors.

Those looking for a taste of the exotic could pose for pictures on a camel. The setting was made more realistic with dancing girls, roaming salesmen, and musical performances in a giant tent. Although admission to the Oriental Village was free, the area was considered a failure and did not return for 1934.

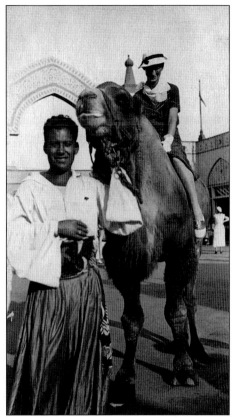

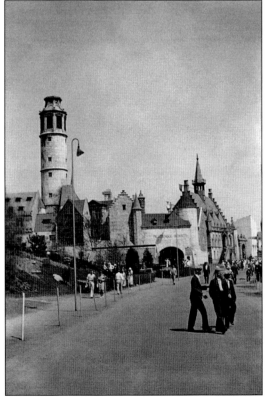

Much larger than the Oriental Village, and much more successful, the Belgian Village was a truly magnificent section of the fair. Designed to resemble a walled Flemish city as it would have looked in the 16th century, the village featured buildings that used molds cast from the actual structures in Belgium. The tall tower on the left featured a carillon that could be heard across most of the fair.

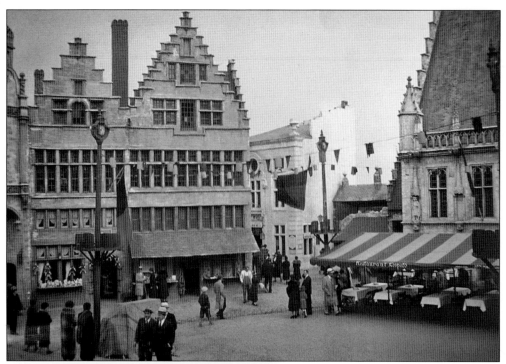

The Belgian Village was not based on any one city. Instead, it was an amalgamation of buildings from across Belgium. The village was quite complete, featuring shops, restaurants, a city hall, and even a full-size church. Belgian craftsmen traveled to Chicago and used traditional building methods and tools to bring the colorful swatch of Europe to life.

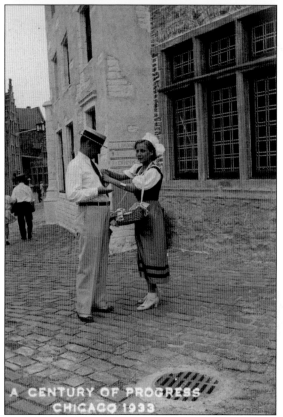

While the Morocco and Oriental Villages featured street beggars asking for money, the Belgian Village found a more subtle and attractive way of parting people from their money as they walked through its cobblestone streets. If numerous photographs are a good indicator, scores of young men were happy to buy flowers from pretty women in native garb.

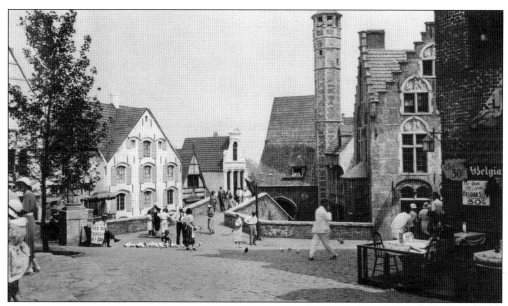

It is hard to believe this picture was taken in Chicago and not in Belgium. There was even water running under the bridge in the center of the scene, and a small paddle wheel driving a mill. The Belgian Village was so successful that portions of it were recreated for Expo 58 in Brussels, and an almost identical copy of the complete village was built for the 1964–1965 New York World's Fair.

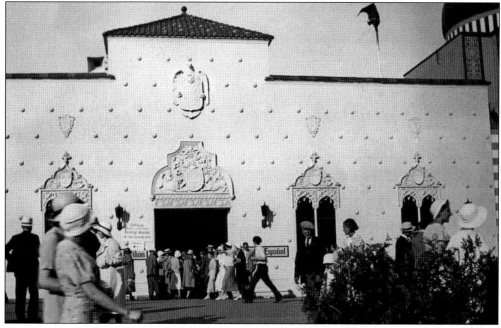

The Spanish Pavilion restaurant was very popular because it was included in tour packages sold by American Express. Billed as the "Official American Express Dining Room," meals were included for guests if they had a tour coupon—or for the stately sum of $1 if they were paying cash. The tour packages, which combined travel, lodging, admission, and most meals, were quite popular with guests from out of the area.

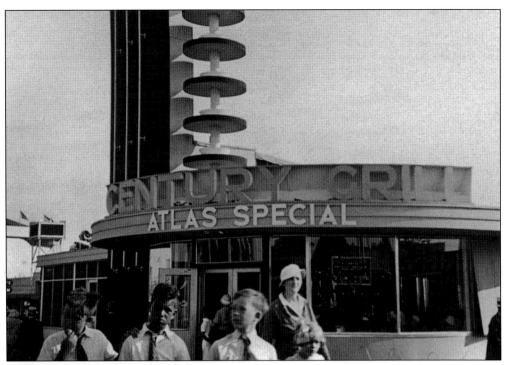

The fair offered a wide variety of international cuisine. Those looking for American fare could turn to the Century Grill, a chain of restaurants located throughout the fair site. This one, near the Midway, advertised Atlas Special, a nonalcoholic malt and hop brew. An exhibit demonstrating how it was brewed and how the alcohol was removed was located in the Food and Agricultural Building.

The A&P supermarket chain sponsored the A&P Carnival Building. The name conjures up images of rides and games of chance, but it actually featured educational displays focused on the business of bringing foodstuffs to market. An experimental kitchen demonstrated new recipes and ways to prepare food. The building was noteworthy for its rotating stage.

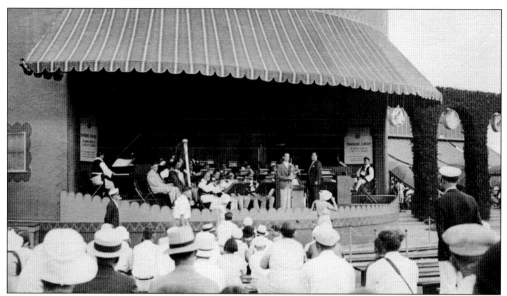

There was entertainment at the A&P Carnival, though, in the form of concert performances by Harry Horlick and the A&P Gypsies, a group that had been appearing on radio for A&P since 1924. In addition to broadcasting their shows from the fair, they also performed several times a day at an outdoor arena that seated 1,000. There were also Gypsy dances, and puppet shows by noted marionette artist Tony Sarg. Food writer George Rector served as the master of ceremonies.

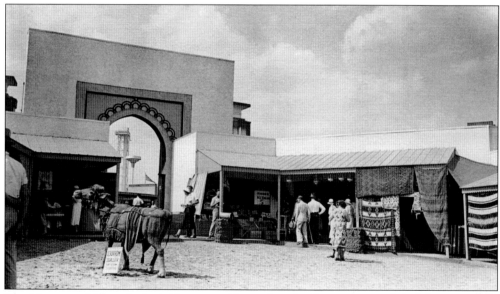

The Moroccan Village had a wide range of items for sale. Some were made in Morocco, while others were fashioned at the fair by native craftsmen. Exhibits touted the nation's tourist attractions on an elaborate relief map, while a gaily decorated shop served up coffees, teas, and Moroccan foods. The sign next to the donkey was printed in reverse to enable guests to take pictures of themselves using a mirror to show them sitting on the Moroccan saddle.

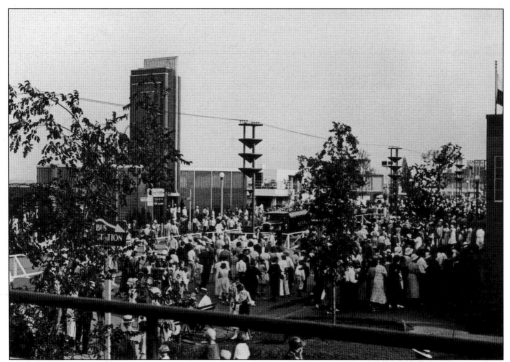

A large portion of the space in the central area of the fair was devoted to the Home and Industrial Group. The exhibits there consisted of a number of small homes that were built with new materials or construction techniques, as well as several larger halls that showcased products for potential new homebuyers. One of the most popular displays was a new scientific marvel—air conditioning.

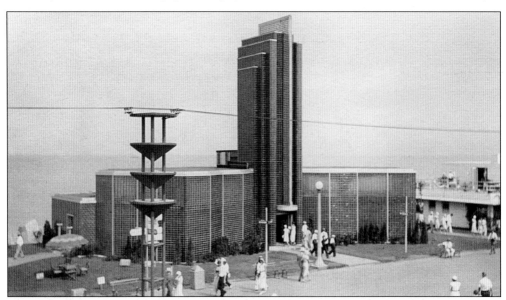

The Glass Block House was not intended to look like a real home, but was built to show how glass blocks could be used in other projects. Steel framing was used for the 50-foot tower, but the lower walls were built using only glass blocks to show their strength and durability. The blocks were cast in a variety of colors, ranging from pale yellow on the tower to deep purple near the ground.

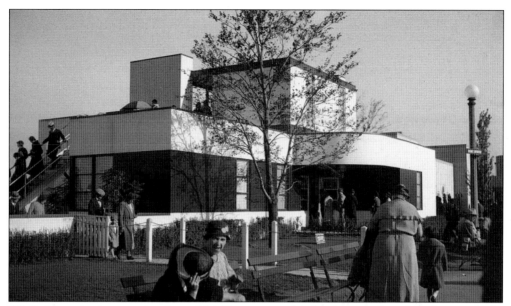

While Masonite is a commonly used building material today, it was relatively unknown at the time of the fair, having only come onto the market in 1929. The Masonite House used the pressed laminate material for both the exterior and interior walls, and also for the floors, to demonstrate its versatility. Much of the interior décor was also of man-made material, such as cellophane drapes.

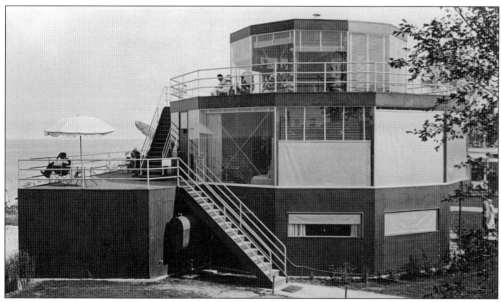

The House of Tomorrow relied extensively on air conditioning for cooling, as many of its walls consisted of large fixed glass panes. A steel core provided support for the open-space floor plan, but the most unusual design element was probably an airplane hangar at the lowest level, which reflected a belief that families of the future would have their own airplanes.

People who liked things good and solid were likely drawn to the Brick Manufacturers' House. Bricks were used everywhere, including the exterior and interior walls, planters, and fountains leading into the hexagonal structure. Even the ceilings and floors were made of bricks, with the floors polished to a high gloss to disguise the material. Hidden steel rods were used to reinforce the structure.

The builders of the Cypress Log Cabin were not predicting a resurgence of people wanting to live in log cabins; rather, the exhibit was intended to show the versatility of cypress for incorporation in other designs. After the fair ended, the cabin and several other model homes, including the House of Tomorrow, were moved to the Indiana Dunes National Lakeshore Park on the shore of Lake Michigan, where they still reside.

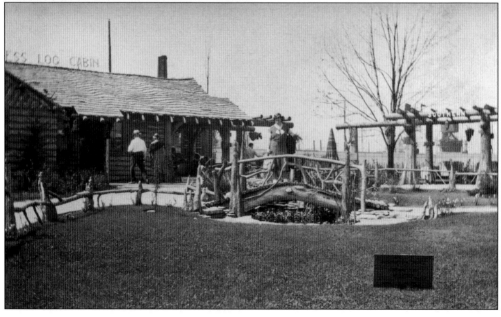

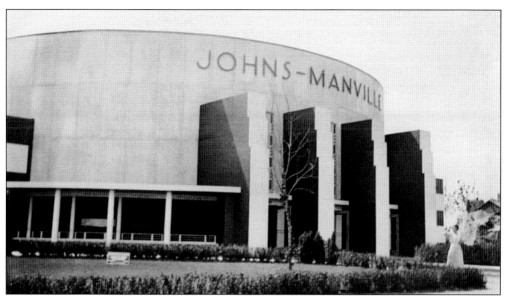

The Johns-Manville Corporation operated one of the larger pavilions in the Home Furnishings Group. Much of the display area was devoted to the "wonder material" asbestos, long before the dangers of it causing cancer were realized. There were also exhibits showing how the company's products could be used to modernize existing structures.

Much of the fair infrastructure was itself a futuristic look at building designs, materials, and technologies, such as this fanciful streetlight. The fair corporation allowed some exhibitors to donate items in exchange for free publicity, but this badly backfired when they allowed a company to install pay toilets in an attempt to save the cost of building them. A tremendous amount of bad publicity led to free rest rooms for 1934.

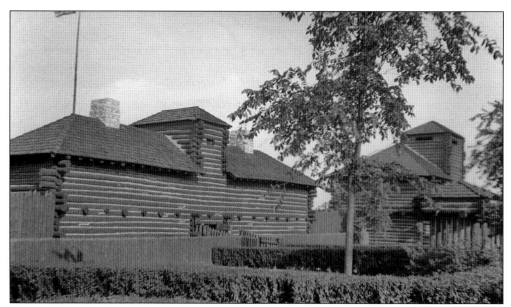

The center section of the fair site also included several historical venues. The wooden blockhouse and barracks of Fort Dearborn were built using the original plans for a fort that was conquered by the Potawatami Indians during the War of 1812. The battle was brief, lasting only 15 minutes, but all of the defenders were killed or captured in what is now known as the Dearborn Massacre.

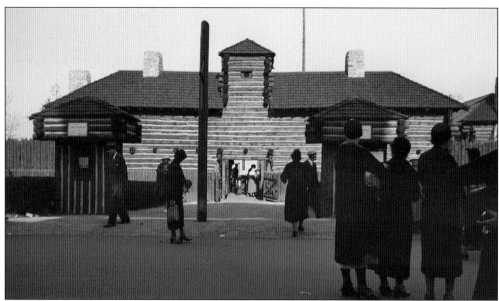

The recreated fort was well received and was featured on a US postage stamp that was issued to celebrate the fair. When the fair closed in 1934, the fort was left in place with the plan to make it a permanent exhibition; an endowment was provided by the fair corporation to support it. Sadly, the buildings were later heavily damaged by a fire, and it was demolished in 1939.

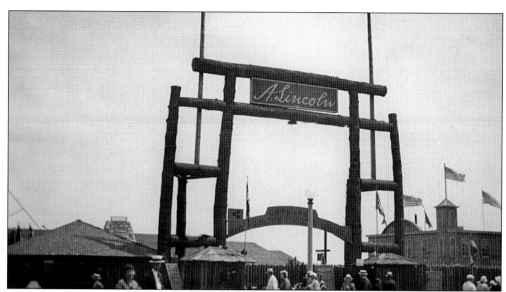

Illinois did not officially adopt the slogan "Land of Lincoln" until 1955, but in 1933 it was still quite proud of Abraham Lincoln's time in the state, which led to another historical stockade. The Lincoln Group, also known as the Lincoln Village, included reproductions of five historic buildings from the revered president's life and career. Both Fort Dearborn and the Lincoln Group were part of the 1932 preview tours.

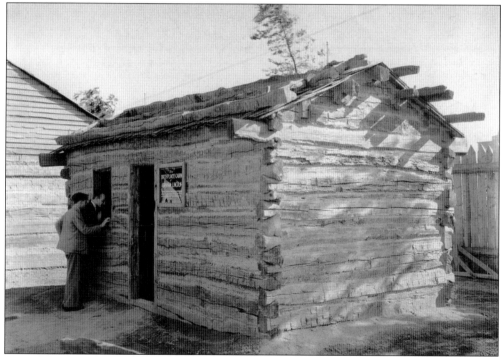

One of the main attractions in the Lincoln Group area was this re-creation of the cabin where the 16th president was born in Hodgenville, Kentucky, in 1809. To make it as realistic as possible, it was constructed from timber taken from other structures built during the same period as the original cabin. Vintage furnishings completed the effect.

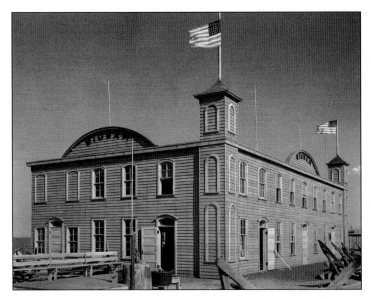

The Wigwam was the meeting hall in Chicago where Lincoln won the Republican nomination for president in 1860. While the other buildings in the Lincoln Group were full-size recreations, the Wigwam was built in a reduced scale due to the massive size of the original structure. The real Wigwam could hold 12,000 people, far more than those visiting this copy on any given day of the fair.

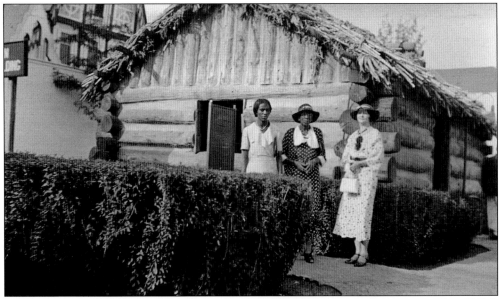

Another recreated Chicago landmark was the De Saible Cabin, originally constructed in 1777. It was the first home of Jean Baptiste Point de Saible, the black man who is said to be the founder of Chicago. His last name today is generally spelled as Point Du Sable. The exhibit was moved several times during the fair, some say reflecting the second-class status accorded to blacks at the fair itself.

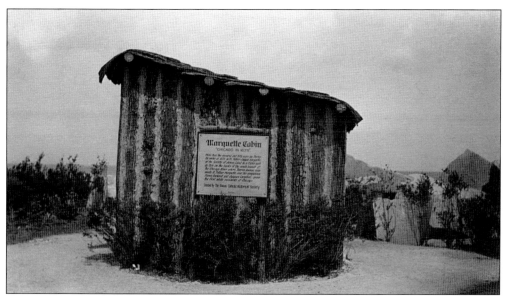

The Marquette Cabin was a re-creation of a small hut used during the winter of 1674–1675 by Father Jacques Marquette, one of the first white settlers in the area. The original cabin stood on the banks of the Chicago River, near where Damen Avenue meets it today. Marquette, a French Jesuit missionary who explored much of what today is Wisconsin, Michigan, and Illinois, died in Chicago in May 1675.

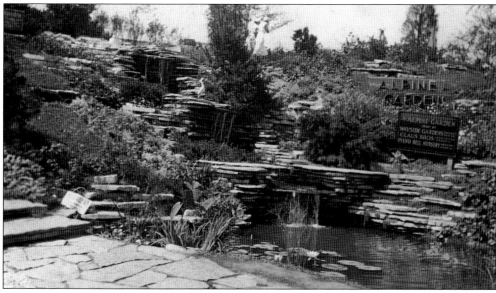

While most of the fair's garden displays were located near the lagoons, there was a sizeable one in the center section as well. Covering a half-acre plot, the Alpine Gardens actually included plants from around the world, not just alpine regions. Weary visitors could rest their feet as they watched water flowing over a series of rock ledges into a pool stocked with colorful goldfish and water lilies.

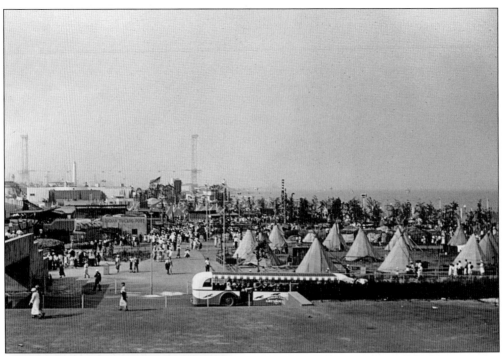

The Indian Village was one of the largest exhibits at the fair, covering more than three acres. During the first season, 190 members of six Native American tribes actually lived on the site. The village was divided into small groups that featured their unique styles of dwellings, including teepees, wigwams, adobe houses, and earth-covered hogans.

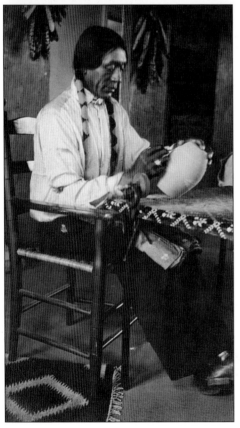

Visitors could buy a variety of souvenirs, including highly sought-after Navajo rugs, children's toys, and a wide range of apparel and jewelry. Many of the items were handcrafted on site, allowing guests an opportunity to see the artisans practicing their traditional skills. They could also watch the families at play and preparing their meals.

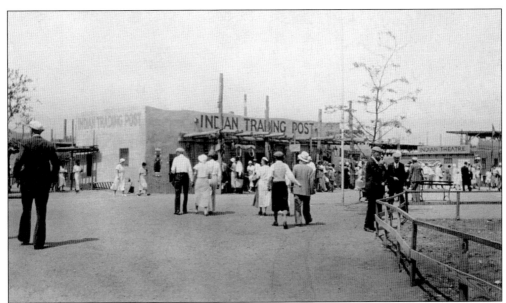

The fair's Indian Trading Post operated much like those in the days of the Old West. In addition to offering Indian merchandise for sale, it was also where the residents of the Indian Village got their food and other supplies. Admission to the Indian Village was free; the concession was funded by sales at the Trading Post and the adjoining Indian Theater.

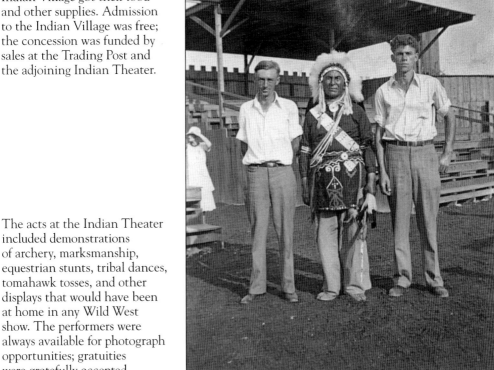

The acts at the Indian Theater included demonstrations of archery, marksmanship, equestrian stunts, tribal dances, tomahawk tosses, and other displays that would have been at home in any Wild West show. The performers were always available for photograph opportunities; gratuities were gratefully accepted.

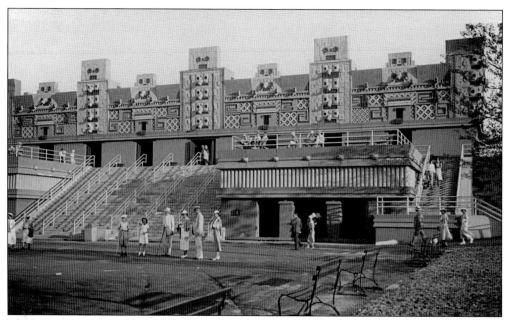

The Maya Temple stood on the highest point of the fairgrounds, making it one of the most visible exhibits in the center section. It was created using molds cast at the Nunnery of Uxmal, an actual temple in the Yucatan jungle. The fair had originally planned to recreate the entire temple, but funding only allowed for a scaled-down version of one wing.

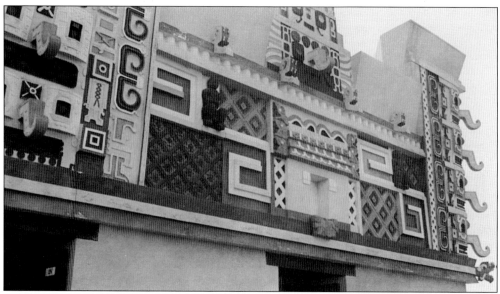

A team of scientists from Tulane University spent two seasons in the jungle working on the molds and research needed to recreate the temple. It is unfortunate that color photography was not yet available to capture the details of the Maya Temple and other aspects of the Century of Progress Exposition; by all accounts, the carvings on this building were quite spectacular and colorful.

Five

THE SOUTH END

Chicago has long been famous as a transportation hub. While most people today are likely to think of O'Hare airport in that regard, during the time of the fair, the city was one of the major railroad hubs of the nation. Many of the transcontinental rail routes passed through Chicago, both for freight and passenger service. The ease of reaching Chicago by rail was of great importance to the success of the fair, as it relied heavily on visitors from outside the region. This same ease of access also made it possible for many railroads, even those that did not normally travel to Chicago, to participate in the fair.

Transportation became the dominant theme for the southern end of the fair. As part of the overall design strategy, the fair corporation had made an early decision to place the Travel and Transport Building, one of the fair-sponsored pavilions, in that area in the hope of attracting similar exhibits. The plan worked, and in addition to the hoped-for rail participation, the area also became home to major exhibits from General Motors and Chrysler Motors. Conspicuously missing was any exhibit from Ford, which did not have faith in the fair's ability to help sell cars. Amazed at his competitors' successful exhibits in 1933, Henry Ford would make a major strategy change for the following season.

The south end of the fair also had several exhibits that fell outside the transportation theme, seemingly to fill in available space without any particular thought as to an overall theme. There were two out-of-place international exhibits, some Wild West shows, and other small amusements, but most were ignored by the crowds as they looked for the newest in planes, trains, and automobiles.

The General Motors Building was truly impressive; measuring 429 feet long, 306 feet wide, and capped by a 177-foot tall tower, it was visible from much of the fair grounds and the surrounding neighborhood. It took 1,100 pilings to support the structure, which was divided into two large exhibit halls separated by a large cathedral-like space. Massive signs, brightly illuminated at night, showcased the company's various brands.

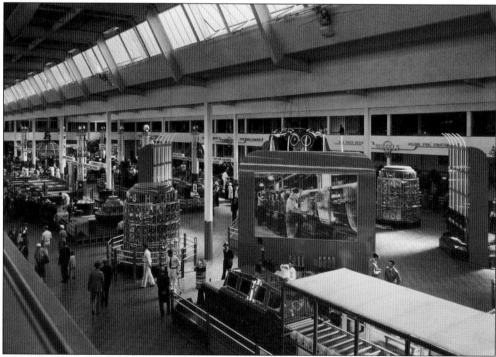

The highlight of the General Motors exhibit was a fully functional automobile assembly line. At the end of each day, the completed cars were driven out of the fairgrounds in a parade. Publicity materials stated that visitors could pick out the exact configuration of their cars, watch them being built, then drive them home at the end of the day. Contests were held periodically with one of the cars as a prize.

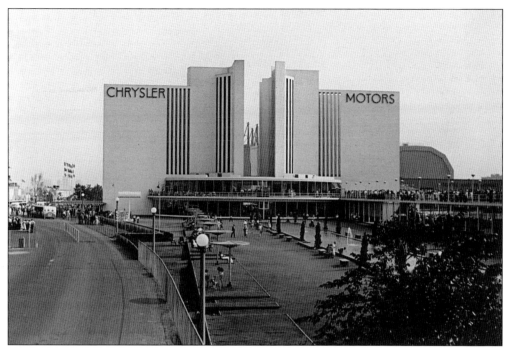

With four 125-foot towers surrounding a glass-enclosed central display area, the Chrysler Motors pavilion was quite impressive. Inside were powerful devices to test the company's cars as guests watched while the vehicles were checked for strength and their ability to withstand heat, cold, and water. A large showroom allowed visitors to check out the latest models of the company's cars and trucks.

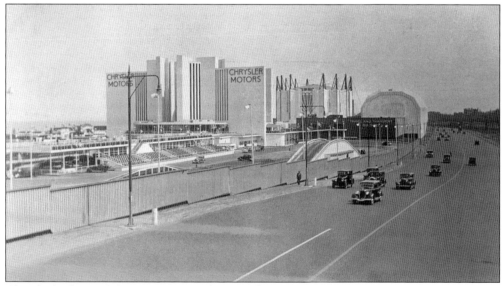

Chrysler had one of the more exciting shows at the fair. Famed stunt driver Barney Oldfield and his "Hell Drivers" raced their cars around an oval-shaped course, seen here from the 31st Street Entrance, performing a series of breath-taking maneuvers. In one spectacular stunt, they flipped a car at high speed, and when it finally stopped rolling, drove it off to demonstrate the durability of Chrysler's products.

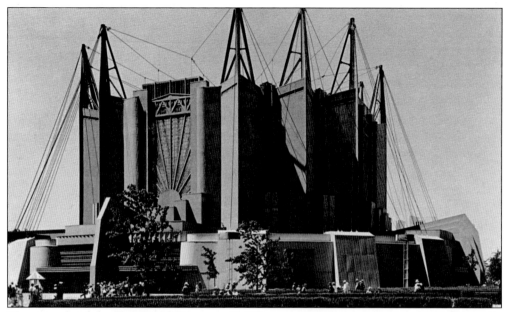

The rotunda of the Travel and Transport Building was constructed using techniques usually employed to build bridges. Cables that hung from 12 steel towers supported the building's roof, thereby providing a massive display area free of supporting interior columns. The building proved to be larger than needed for transit displays and portions were leased to several countries for their national exhibits. Even with that, much of the second floor went unused.

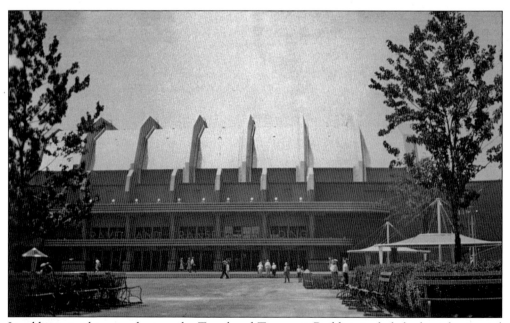

In addition to the rotunda area, the Travel and Transport Building included a large horizontal display hall. Inside were displays of many famous trains and other vehicles that had helped Chicago, and the nation, expand. Guests could explore actual stagecoaches and Conestoga wagons that had opened the West to development, marvel at a locomotive that had first traveled to Chicago in 1858, or walk through displays of early cars and airplanes.

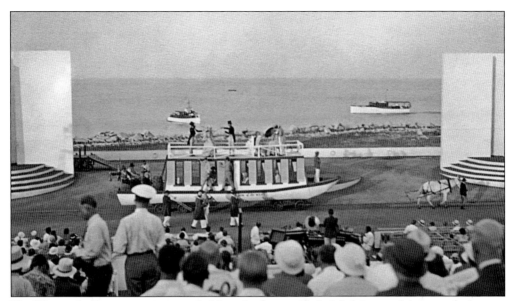

The Wings of a Century pageant was held on the shores of Lake Michigan and showcased advances in transportation in a 17-act spectacle that included 70 horses; 15 trains, some of which were shown operating under power; a small flotilla of ships; and a variety of antique cars, trucks, and fire engines. Even modern air travel was included as planes flew past the stage. Here, an Erie Canal boat "arrives" in Albany, New York, in 1825.

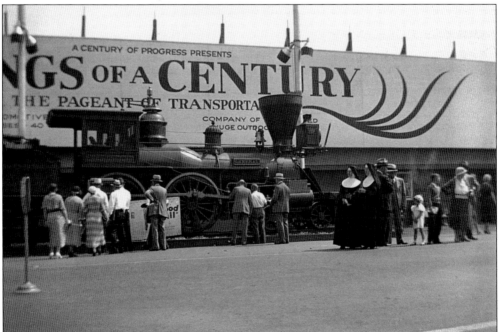

The show gathered famous trains from across the country, including *The General* of Civil War fame. Stolen by Union forces in a raid that led to the creation of the Medal of Honor, *The General* was restored so it could travel to Chicago under its own power. The engine later appeared at the 1939–1940 and 1964–1965 New York World's Fairs and is now on permanent display in Kennesaw, Georgia.

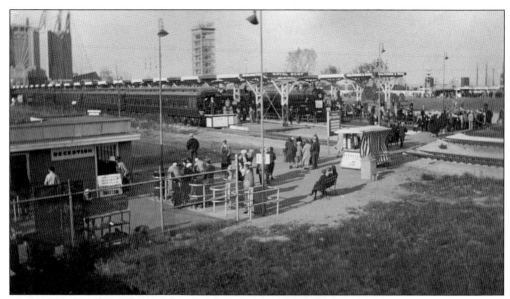

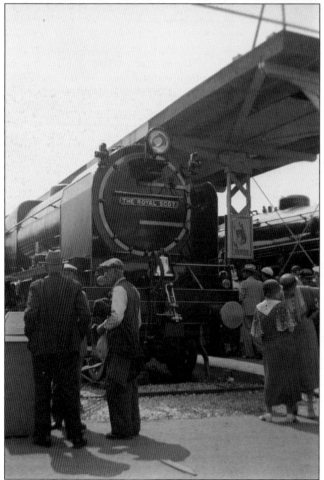

Railroad enthusiasts must have been thrilled with the fair, as there were many groups of trains to explore. The Outdoor Railway Exhibit was a collection of full-sized trains, complete with passenger and freight cars, which were open for tours. Rail travel was still the main method of long-distance travel at the time, and the area was well attended.

Great Britain loaned the famous Royal Scot train, which provided express passenger service between London, England, and Glasgow, Scotland. Guests could look into the cab of the 158-ton locomotive, then stroll through eight lavishly appointed dining and passenger cars. The train was very popular and attracted 2,074,348 visitors. After the fair ended, the Royal Scot went on a tour through the United States and Canada before being shipped back home.

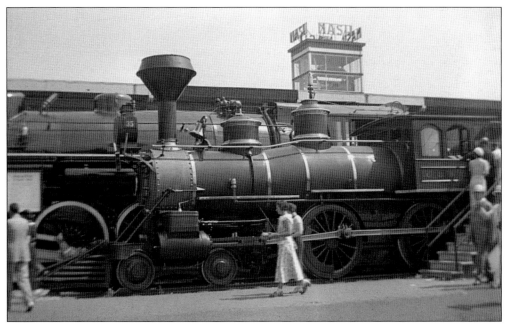

The Burlington Railroad had a large display of its newest and most powerful trains, with an emphasis on the luxury of its passenger cars. The most popular part of its exhibit, though, was Locomotive No. 35, *The Pride of the Prairies*. Built in 1882, the engine was paired with a replica of the nation's first mail sorting car. Much of the nation's mail was still routed by train in 1933.

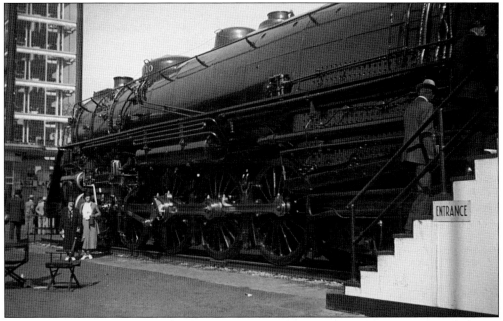

When the plans for the fair were being prepared, some designers argued against extending it so far to the south, fearing they would run out of exhibits to fill the space. Others took a "build it and they will come" approach, arguing that the railroad industry would participate as the site was so close to a major rail line. Happily, the railroads did come through with some massive displays of rail power.

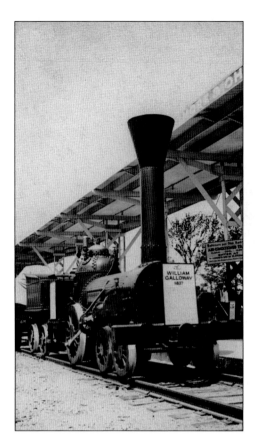

Many of the nation's famous trains had been scrapped over the years in the name of progress. Several of the railroads commissioned working replicas, such as this display from the Baltimore and Ohio Railroad, to demonstrate how far they had come since their early days. This engine was a replica of the 1830s *Lafayette*, but it was renamed for the fair after a then-current company executive.

The southern end of the fair also included the 101 Ranch, which was a Wild West show based on a long-running attraction of the same name near Ponca City, Oklahoma. It featured displays of trick shooting, roping, riding, archery, and tomahawk throws. It failed to generate much interest and did not return in 1934.

More fun out West was available at Days of '49, which billed itself as a rip-snorting reproduction of the town of Gold Gulch from the California gold rush. "Old time fun and amusement" were promised, but only after paying "Ten cents a head" at the "toll booth." Children were admitted for only 5¢.

Once inside, guests could stroll the dirt streets of the recreated frontier town, stopping in the saloon or dance hall for a break from the heat of a Chicago summer. Suitably refreshed, they would be ready to watch a gunfight on the main street, with the inevitable loser taken to the undertaker's parlor, shown here. Many of the items on display were vintage items actually used in the Old West.

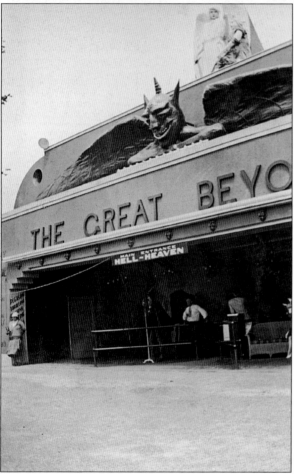

Another bit of Western fun was found at Rolleo, the logrolling equivalent of a rodeo, where the audience sat around a large open-air tank of water that held several giant logs. There were a number of different acts, including trick displays by champions of the sport, a contest between enthusiastic performers, and a clown act that made logrolling look far easier than it actually was.

The Great Beyond exhibit would have looked more at home in the Midway area. It professed to explain what was waiting after death, in either heaven or hell, in comical terms—and for only 15¢. Most people seemed not to be interested; like Rolleo, it did not return in 1934.

The small barn on the left looks out of place among the more futuristic buildings in the background. There were several animal exhibits in the south end of the fair, including a collection of dogs, horses, cattle, and poultry. It was claimed that the largest horse and cow in the world were both on display. Exhibits also showcased modern techniques for raising animals and for milk production.

The largest collection of animals was at the Poultry Show, which was sponsored by the National Poultry Council. Hens from 28 states and five nations vied for the honor of laying the most eggs during the fair. It is not clear what the prize was or who won. There were also displays of rare fowl from around the world.

The Ukraine Pavilion was one of the largest of the international pavilions. Constructed of logs, it was a striking and beautiful design. Inside were art exhibitions, craft and souvenir shops, and a well-regarded restaurant. There were also periodic folk dance and song performances by members of Chicago's large Ukrainian immigrant population. Many of the items on display are now held by the Ukrainian Museum in New York City.

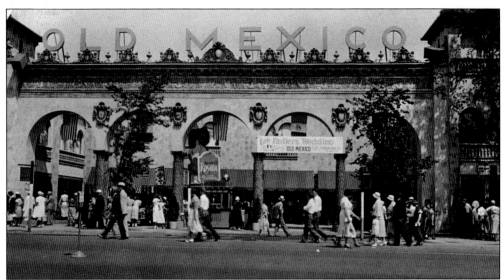

Perhaps one of the log rollers at the Rolleo show found love at the fair, for the sign in front of the Old Mexico exhibit announced his wedding to be held there on August 25, 1933. More traditional Mexican celebrations and dances were held there throughout the fair, but the highlight was the nightly performances of scantily clad señoritas emulating the fan dancers who were so popular in other shows.

Goodyear blimps have been a popular sight in the skies above major events in the United States since 1925. Goodyear stationed two of its airships at the fair, selling short excursion flights of 15–20 minutes for $3. The rides promised a leisurely view of the fair, but it was said that the winds off the lake made the landings a very memorable event. The blimps also could tow advertising banners.

Adventurous guests could take a tour of Chicago aboard a fleet of seaplanes based at the fair. The company also offered scheduled trips to several local airports for those who wanted to travel to the fair in style. Sadly, one of the flights ended in tragedy when the plane suffered damage in a sudden storm and crashed, killing all nine aboard. Even so, the flights continued for both seasons.

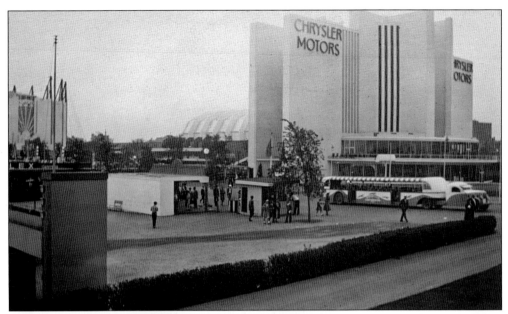

By the time guests had walked the length of the fair site, they were undoubtedly glad to see one of the special Greyhound buses available to carry them back to their parking lot or train station. Some of the buses traveled slowly across the fair making numerous stops, while others on an express route took about 15 minutes to get from one end to the other. Some buses operated all night to transport fair employees across the grounds.

There was also a fleet of 39 rickshaws that could be hired, complete with tour guides. The rickshaw pullers were almost all college athletes, and they seemed to be particularly popular with younger female riders. The rides were fairly expensive though at $1.40 per hour plus tips, especially as they could seat only one passenger.

Six

THE 1934 FAIR

Like the world's fairs before it, the Century of Progress Exposition was originally planned to operate for one season. However, the budget for 1933 had been based on greatly inflated attendance estimates—a common problem with most fairs, it seems—and, as a result, the fair found itself unable to pay back its bond holders. Rather than give up and accept the losses, the fair and many of its concessionaires decided instead to move forward with a bold solution to their problem: they would reopen for a second season in the hope that it would turn a profit.

At first glance, this would seem like a classic case of throwing good money after bad, but the decision was actually a sound one. Much of the cost for 1933 had gone into infrastructure and exhibits, meaning that those sums would not be incurred again in 1934. The fair corporation also made changes in its staffing and financial operations, which resulted in significant cost savings. The biggest factor that contributed to the eventual profitability of the fair, though, actually did involve spending more money.

The 1933 season had shown that some exhibits were utter failures, while others, particularly the international displays such as the Belgian Village, were quite successful. More than 100 buildings from the first season were razed, and a host of new concessionaires rushed in to build more than a dozen villages, allowing the fair to claim visitors could "tour the world in a single day."

There were a number of additions for 1934 besides the villages. The Ford Motor Company more than made up for missing the 1933 season by spending more than $2.5 million on exhibits that employed more than 800 people. A number of companies took advantage of the end of Prohibition and opened restaurants, bars, and night clubs, all of which proved to be quite popular with crowds that had been waiting years for a legal drink. Many of the remaining 1933 pavilions were expanded or spruced up to provide new exhibits.

The additional $5 million spent to improve the fair proved to be a worthwhile investment, at least for most of the exhibitors, and when the books were finally closed, the fair had turned a tidy profit of $160,000, which was donated to charity.

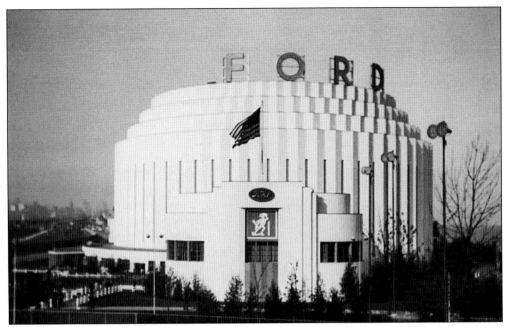

Ford sponsored four different exhibits for the 1934 season. The main one, the 585-by-235-foot Industrial Hall, highlighted the manufacturing of the many parts needed to build a car. Inside a 200-foot diameter rotunda building, which was said to resemble the stacked cogwheels of a giant machine, were displays of 67 vehicles, ranging from ancient carts to the latest Fords. After the fair ended, the rotunda was moved to Dearborn, Michigan. It was destroyed in a fire in 1962.

Convinced that soybeans were the plant of the future, Henry Ford had an 1863 barn moved from his childhood home to the fair and named it the Ford Industrialized Barn. Inside were machines that used mechanized belts to speed the process of turning soybeans into a variety of products. The mechanism would have looked at home in one of his automobile factories. The barn is now on display in Dearborn, Michigan.

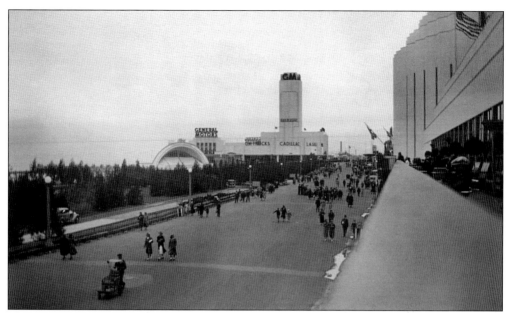

The centerpiece of the three-acre Ford Symphony Gardens was Roads of the World, where sections of 19 famous roadways, including the Appian Way, the Oregon Trail, the Lincoln Highway, and India's Grand Trunk Road, were recreated on a three-quarter-mile loop. Guests were driven through the display in new Ford cars to demonstrate how well they handled a variety of surfaces and conditions. Walking paths allowed a more leisurely view of the gardens.

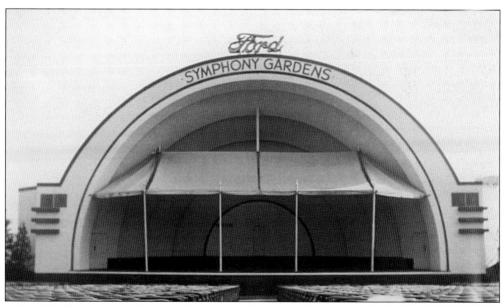

A band shell at one end of the gardens provided a setting for concerts by the Detroit Symphony Orchestra, the Chicago's Woman's Symphony Orchestra, the Mormon Tabernacle Choir, and other groups from across the country. Many of the performances at the 2,300-seat theater were broadcast on the radio and reached an estimated 10 million listeners per show, which generated a wave of positive publicity for Ford.

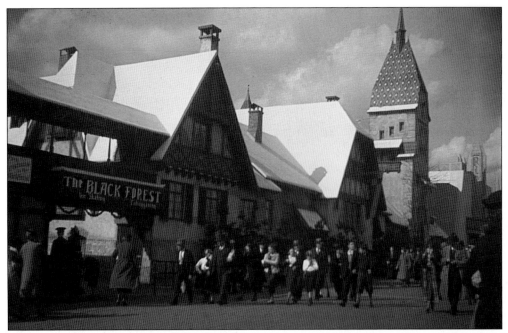

Snow-covered buildings in the middle of summer? That was one of the attention-getting designs of the Black Forest, an elaborate addition for 1934 that was based on that region of southern Germany. The success of the Belgian Village and similar attractions in 1933 generated a whole host of new villages for the second season. The Black Forest was one of the largest and most photogenic.

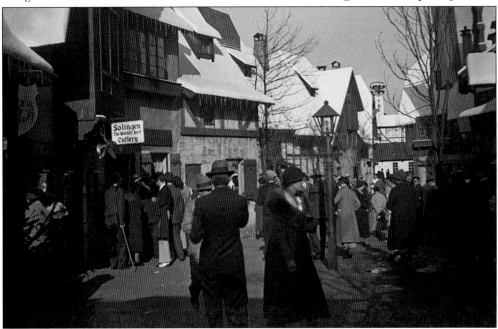

One of many exhibits at the fair that took advantage of the end of Prohibition, the Black Forest featured several restaurants, beer halls, and other spots to enjoy a cold drink. There were also shops offering souvenirs and foods imported from Germany, with cuckoo clocks reported as being among the best sellers.

While most of the snow and hanging icicles at the Black Forest were fake, there was one large section that was covered in real ice. A state-of-the-art freezing system allowed skaters to perform on what was billed as a "frozen millpond." In addition to displays by professional skaters, guests could rent a pair of skates and take a turn out on the ice, which was quite a novelty during a Chicago summer.

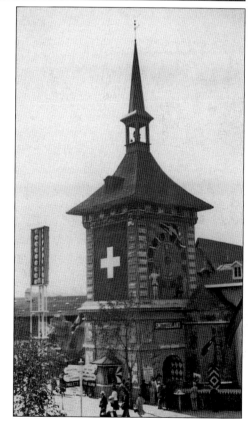

Visitors looking for a touch of Alpine fun could also visit the Swiss Village, which cost more than $250,000 to build. Like the Belgian Village, many of its buildings, such as this copy of the Kramgasse clock tower, were constructed using molds made of actual structures. Most of the buildings were from Berne, the capital of Switzerland, and were built in part by Swiss craftsmen who traveled to Chicago for the job.

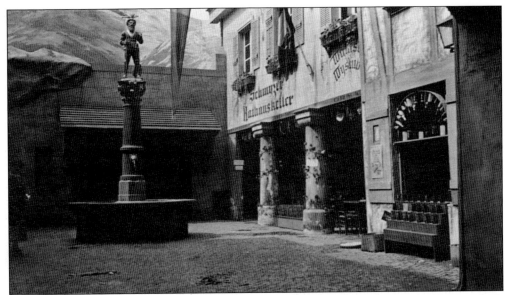

At the center of the Swiss Village was a copy of the Schutzenbrunnen fountain in Berne, which dates to 1603. Shops on the town square were staffed by Swiss clock and lace makers, who were imported for the fair, or by shopkeepers selling Swiss products. Ironically, the original statue in Berne was heavily damaged in 2013 in a move planned to protect it, and a copy will be put in its place instead.

A 200-foot-high painting of the Alps provided an atmospheric backdrop for troupes of Swiss dancers, yodelers, and alpenstock players. The Swiss Village also featured several animal acts, including a pair of dogs imported from the Hospice at the Great St. Bernard's Pass, two bears in a bear pit copied from one in Berne, and wandering goats and cows. At least one guest sued when her clothing was eaten by the goats.

If not for the Sky-Ride in the background, this picture would appear to be of the real Weinstube Zur Grossen Reblaube restaurant in Zurich. The detailed replica accurately copied the painted front of the original. Reacting to complaints about the low number and poor quality of restaurants during the 1933 season, the fair organizers made a concerted effort to attract more eateries for 1934.

Replicas of the Old North Church and the old Boston Statehouse towered over the rest of the Colonial Village, a collection of 18th-century landmarks from the original American colonies. Among the exhibits were copies of the homes of Paul Revere and Betsy Ross, the House of the Seven Gables, the Governor's Palace in Williamsburg, Virginia, and Benjamin Franklin's printing shop in Philadelphia.

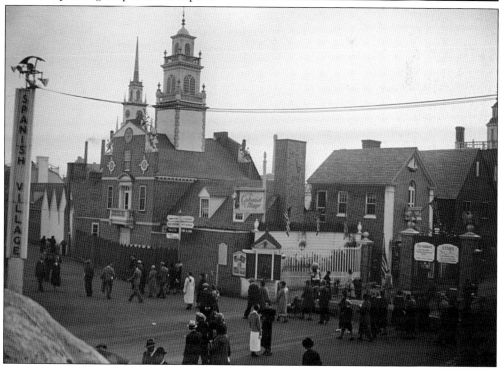

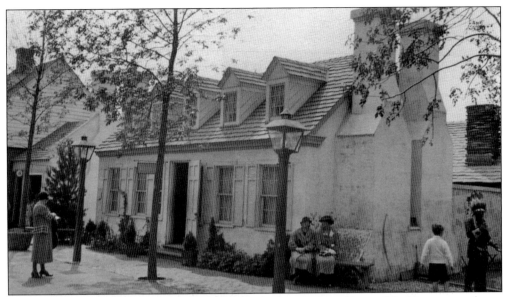

This building was billed as a copy of Wakefield, the home where George Washington was born. In reality, the actual design of Washington's first home is unknown, and the fair house was, in fact, a copy of a house built in 1931 on the former Washington estate to show what the original house might have looked like. The 1931 replica is now part of the National Park System.

Another George Washington home was part of the Colonial Village. Staffed by members of the Daughters of the American Revolution, the copy of Mount Vernon included antique furnishings similar to those in the actual residence. After the fair ended, the replica Mount Vernon became a home in Beverley Shores, Indiana, along with the Old North Church and several other buildings from the village. The church, minus its steeple, is the only one of the village structures still there today.

Hungry guests could enjoy "early American dishes and Colonial atmosphere" in the Virginia Dare and Wayside Inn restaurants. Shows were held outside on the village green. A rolling hoops contest was held every Thursday, when admission to the fair was just 5¢ for children. The village staff wore period clothing, much like Colonial Williamsburg in Virginia today.

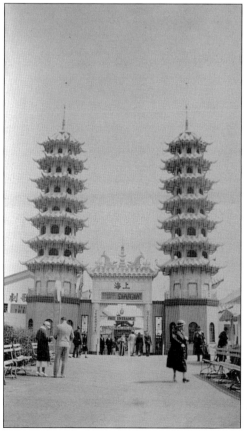

The Streets of Shanghai exhibit replaced the Chinese Village from 1933. Two brightly colored, eight-story pagodas stood on either side of the entrance. Inside were narrow streets decorated with thousands of paper lanterns, and shops offering traditional Asian merchandise such as silks, jades, and porcelain. Most of the material was actually from Chinatown in San Francisco.

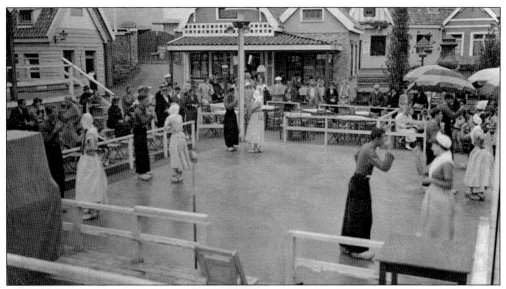

The Dutch Village was a representation of a fishing village, complete with small boats floating in canals, a large windmill, and a recreated Dutch dairy farm. Shops selling goods from Holland lined a central square, where dances were performed by gaily dressed "villagers." Edam cheese was produced on site and sold in a variety of sizes in its traditional red wax packaging.

Like most of the other villages, the Dutch Village was incredibly detailed, especially considering that the buildings would only be used for a short six-month season and then demolished. While a certain amount of effort would be expected in areas designed to produce revenue, such as shops and restaurants, little touches like this well went a long way towards making visits to the villages quite memorable.

Looking at this tranquil street scene in the Irish Village makes it hard to realize that throngs of fairgoers were passing by just outside. Attendance figures for the individual villages varied; those featuring shows of scantily clad women drew the largest crowds, but all appear to have been popular with families. Doubtless there was more than a touch of homesickness for "the old country" among many of the guests.

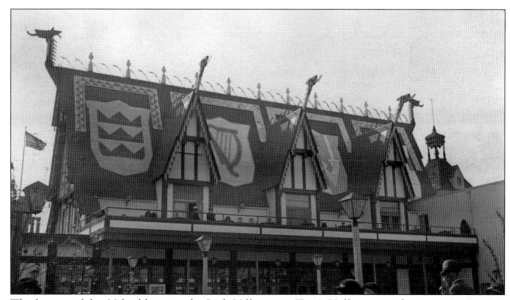

The largest of the 30 buildings in the Irish Village was Tara's Hall, a copy of an ancient meeting place for Irish kings and nobility, which housed a restaurant and shops. Other exhibits ranged from a 12th-century harp and a copy of the Book of Kells, the oldest Irish recorded history from the 8th century, to displays on modern agriculture, industry, and tourist sites.

The village green was the site for a steady stream of folk dancers, musicians, poetry readings, Irish fashion shows, and art exhibits. There were also frequent displays of boxing by members of the Catholic Youth Organization, and, of course, performances by Irish tenors.

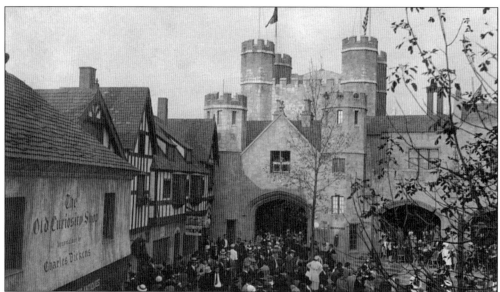

Walking through the gates of the Tower of London and past its "Beef Eater guard" would bring guests into Merrie England. Among the many famous structures copied there were Anne Hathaway's cottage, William Shakespeare's home, and the Old Curiosity Shop, made famous in Dickens's novel of that name. The shop was complete with actors portraying Little Nell and her grandfather, who stayed in character to the delight of visitors.

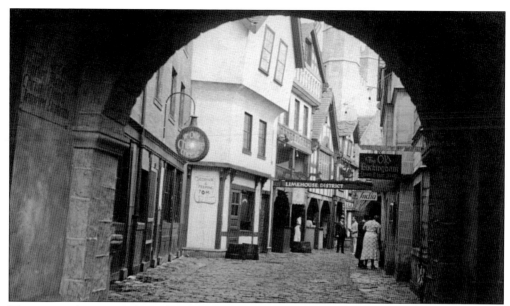

There was a lot to see along the twisting streets recreating 16th-century England. Here in the Limehouse District, shoppers could buy cheese, linen, Indian teas, lace, and other British goods. They also could eat at the Cheshire Cheese Pub or take in a show featuring Lady Godiva and Peeping Tom. Those looking for a different pastime could visit Stokes Poges Church, where Thomas Gray wrote "Elegy in a Country Churchyard."

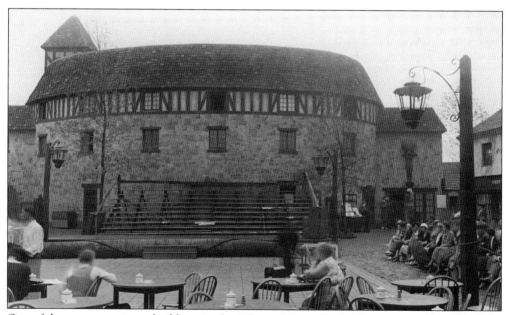

One of the most prominent buildings in the 2.5-acre Merrie England section was the Old Globe Theatre. Shortened hour-long versions of Shakespeare's plays were performed to enthusiastic crowds, and long lines often waited for the next show. After the fair ended, members of the cast took the shows on the road. The building was also used for other shows, such as a radio broadcast by Eleanor Roosevelt.

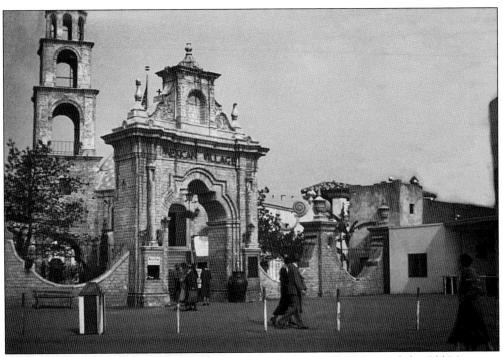

The 1933 season had featured the Old Mexico pavilion, which was basically a peep show featuring scantily clad dancers. A completely new and much larger Mexican Village was built for the fair's second year, and, like its counterparts, relied more on historic architecture than adult-oriented shows to attract patrons. There was an emphasis on Mexican churches, including the famed cathedral at Cuernevaca and the San Francisco Acatepec church in San Andrés Cholula.

The Mexican Village also offered performances by dance and vocal groups; demonstrations of pottery making, painting, and weaving; and Mexican cooking. There were two large dance floors open to guests. A highlight was audience participation in the Mexican Hat Dance. Shopping was an important element as well; this shop offered Mexican cigars.

There were also displays on Mexican industry and tourism supplied by the Mexican government. Many of the items sold in the Mexican Village were made on site. The village was a commercial failure and the operator was forced to declare bankruptcy when the expected crowds failed to materialize. The easy availability of cheaper versions of the same goods in Chicago's own Mexican community undoubtedly did not help sales.

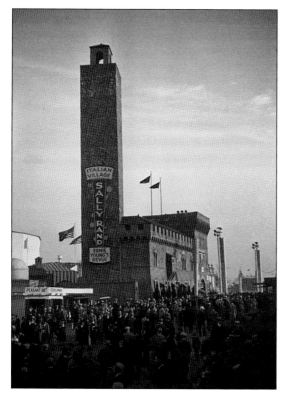

The Italian Village offered a replica of the leaning tower of Bologna (not Pisa) and buildings from Signa, San Gimiagno, Genoa, and other cities, and the usual gamut of shops and restaurants. The main attraction, though, was Sally Rand, who had moved there from the Streets of Paris. The outrage over her famous fan dancing led to a change in her act; in 1934, her new "bubble dance" featured giant balloons.

111

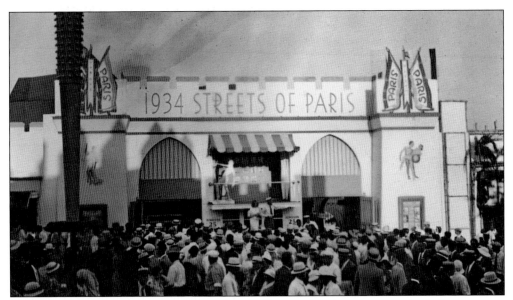

In 1933, there were numerous complaints that the Streets of Paris was too racy, including a protest from the French government. The fair responded by forcing the operators to tone down the shows for 1934 by banning the fan dancers, but then there were complaints that the shows were too dull. The operators tried to lure patrons inside with hints of adult fun, but the loss of Sally Rand was a serious blow, making the 1934 season far less successful than the first.

Not all of the changes involved the many villages at the fair. A noticeable addition was an open-air amphitheater that seated 1,700. It was built by Swift and Company as part of a remodeling of the bridge at the end of the South Lagoon. Concerts were held by the Chicago Symphony Orchestra twice daily, as well as other performances such as the vocal group seen here. The remodeled bridge also featured displays of Swift's meat products.

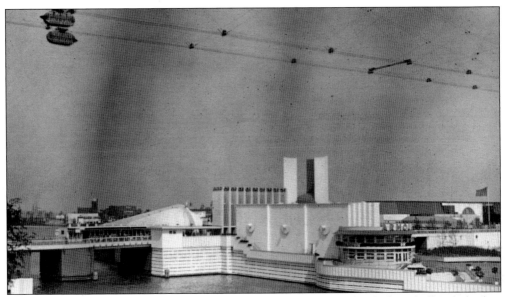

Another bridge, another food company. Armour and Company operated a large hall with displays that showed where their products were sourced, and how they were harvested, processed into packaged foods, and shipped to markets. There was also a display highlighting how waste products from the process could be used in other ways. A restaurant on the shores of the South Lagoon offered a wide variety of meals—all based on Armour products, of course.

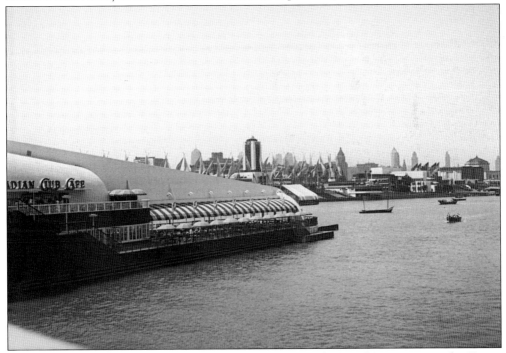

On the opposite side of the same bridge, jutting out into the North Lagoon, was the Hiram Walker & Canadian Club Café. Expansion into the lagoons had been a major priority for the fair management. Projects like these allowed them to fill in what was viewed as dull and wasted space and to house new exhibitors who wanted to be part of the second season.

The North Lagoon also became home to the unimaginatively named A Century of Progress Exposition Fountain. Billed as the world's largest fountain, it stretched 1,000 feet into the water and had a 75-foot diameter ring. The fountain pumped enough water in arcing 35-foot jets to meet the daily needs of a city of one million residents, and the sets of colored lights consumed the power of 150,000 homes.

The empty expanses of the lagoons were also put to use for a demonstration of picking up mail by airplane. The flights were sponsored by Dr. Lytle Adams to demonstrate his new system in the hope of gaining government approval, but it was not until 1939 that real flights began snatching mail from remote lakes and rivers, or from fields in towns too small to justify regular landings.

Standard Oil offered free animal shows in its Red Crown Cage of Fury, where trainer Allen King put 33 lions and tigers through their paces several times a day. The arena seated 2,500 guests, but the shows were so popular that the area was filled by standing-room-only crowds. The shows also included Estrella Nelson and her "psychic elephants." After the show, the crowd was invited to watch the animals close-up in their cages.

Krider's Diversified Gardens was a $10,000 collection of plants from around the world set along a winding path that passed miniature windmills, giant mushrooms, water wheels, and waterfalls. After the fair, the gardens were transported to Krider's headquarters in Middlebury, Indiana. Krider went out of business in 1990, but the gardens were restored by the community in 1995 and can be seen with their world's fair elements today.

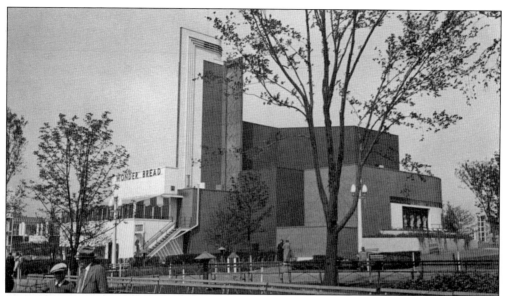

A number of pavilions returned for the second season, looking much as they had the first year but with new tenants. In 1933, this was the Dairy Building; in 1934, it was the home of Wonder Bakery. The main exhibit was a fully functional bakery that turned out an endless supply of Wonder Bread, allowing visitors to watch as the raw ingredients were blended, baked, sliced, and then wrapped for shipment to stores.

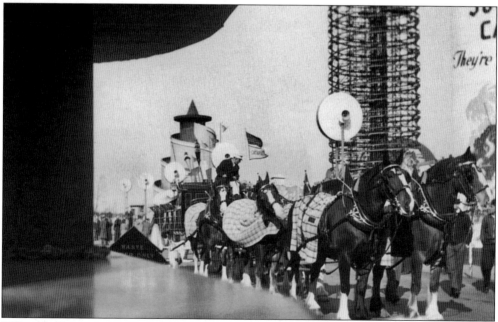

Wilson & Co., a major meat packing company in the Chicago area, employed close to 5,000 people in local factories at the time of the fair. It joined the fair with a six-horse team pulling a traditional meat delivery wagon. A part of the Wings of a Century pageant, the team of Clydesdales also paraded through the fair site; they are seen here in the revised Midway area.

There were some exciting new railroad exhibits for the 1934 season; the biggest crowds were drawn to the Burlington Route's new diesel-powered Zephyr. The streamlined train set a new speed record on the way to the fair, cutting the time for a trip from Denver by half. Visitors undoubtedly enjoyed the fact that the train was air conditioned while on display.

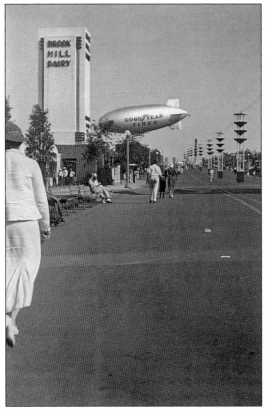

Brookhill Dairy was another new exhibit. It showcased a herd of cows in an ultra-modern setting of a futuristic barn in far-off 1950. Visitors could watch the cows as they ate their meals and were then milked under scientific conditions in a glass-block building designed to let in sunlight. Displays showed the steps needed to process the milk and deliver it to stores.

With Prohibition over, beer was back in a big way. The Brewery Exhibits Building traced the history of beer-making over the centuries, explaining that beer had been produced since at least 6000 B.C. Modern production methods were also on display, from raw materials through each step to produce the beer, including bottling and distribution. Not surprisingly, there was a large cafeteria serving beer at the end of the exhibits.

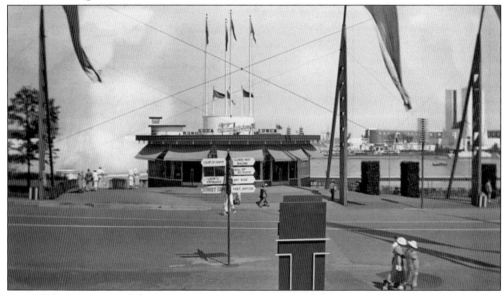

One of the criticisms of the 1933 season was that many of the restaurants were too expensive for families. A number of fast food venues were added in 1934 to address this concern, including several Thompson's Restaurant stands like this one. In an even more popular move, the fair organizers did away with pay toilet concessions, which had generated considerable bad press the first season, opening the comfort stations to all for free.

Seven

THE FAIR AT NIGHT

Very early on during the planning for the fair, the decision was made to put an emphasis on how the fair would look and operate at night. The organizers knew that many local residents would not be able to attend during the day because of work and other obligations, so they wanted to ensure there would be plenty of reasons to go to the fair in the evening. The fair incorporated terms into its contracts with the concessionaires that required them to remain open in the evening, but it soon was apparent that these clauses were not needed. Once word spread about the many fan dancers and peep shows along the lake, the crowds came out in droves.

Not everyone was there, of course, to see women cavorting on stage. Many families came together, and there was plenty else for them to see at night. A variety of family-oriented shows were held across the property, generally until 10:00 p.m., and all of the pavilions were required to be open until then as well. Many people preferred to go at night when the crowds were down, so the fair did a brisk business at night.

From the early days of the fair design, the planners had worked to make sure the fair would be inviting and fun once the sun went down. The fair's architectural commission commented in a report to the board of directors in 1928: "Artificial light, the tremendous progress of which has astonished all designers in recent years, will become an inherent component of the architectural composition." To accomplish this, a radical partnership was formed between General Electric Co. and the Westinghouse Electric & Manufacturing Co. The two normally fierce competitors put their differences aside and worked together to create a truly spectacular nighttime experience. Thousands of lights, miles of neon tubes, giant transformers, and a 12,000-volt electrical system powerful enough for a good-sized city were all needed to bring their dreams to life.

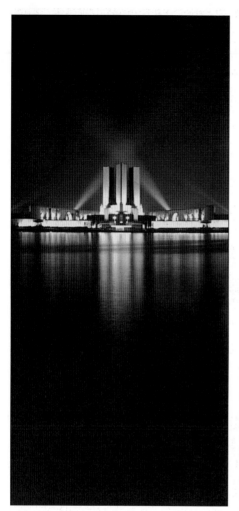

This view of the U.S. Government Building across the wide expanse of the North Lagoon illustrates one of the many challenges the lighting designers faced. They needed to find ways to make the buildings bright enough to be seen at night from great distances but without blinding nearby visitors. A great deal of planning went into the fair's lighting systems.

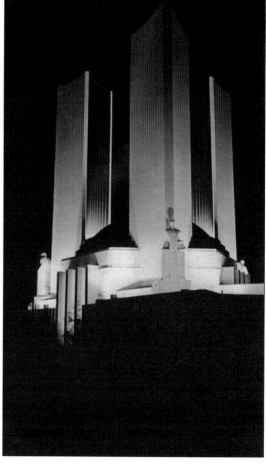

A closer view shows how effective the lighting systems were. The fair organizers had asked the architects to work with the lighting team to incorporate the necessary fixtures and cabling into their designs, and for the most part the partnership was successful. A significant amount of field modification was required, though, when some initial designs did not work as planned.

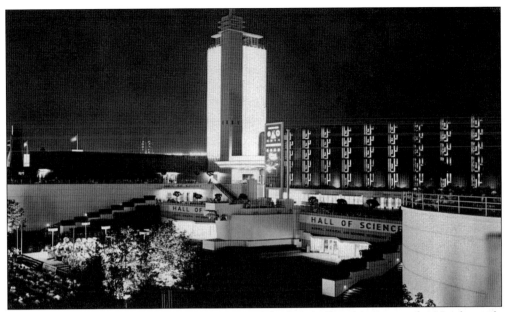

Neon lighting was still relatively new in 1933, and the fair made extensive use of it. Nearly a mile of blue and red tubing was used to illuminate the Hall of Science, in addition to incandescent and fluorescent fixtures. The neon tubes were carefully concealed so that only their reflected light was visible, giving the building a softer and more ethereal appearance. Here, a crowd is enjoying a concert by University of Wisconsin students, with the hall as a brilliant and colorful backdrop.

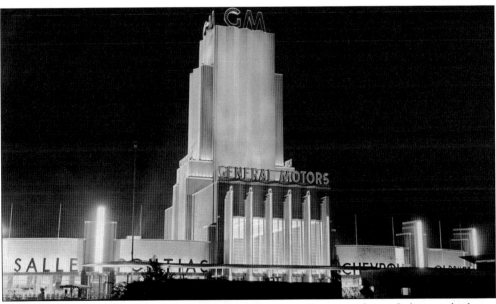

The General Motors Building was another example of excellent use of neon lighting, which was used both for the building's signage and for lighting accents. Incandescent fixtures illuminated the bulk of the building. The fair had strict rules on signage; lights could dim or change color, but blinking signs were forbidden. All signage had to pass a review committee to ensure it would not be too garish or distracting.

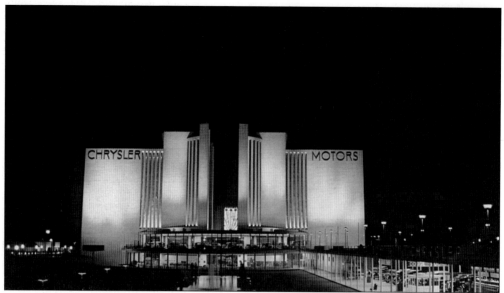

Many pavilions took on a very different look in the evening hours. During the day, reflections kept visitors from seeing much of the displays behind the large plate glass windows of the Chrysler building, but at night these areas became more visible as the interior lighting took over. Film speeds were slow at the time of the fair, making nighttime shots like this quite difficult without the use of a tripod.

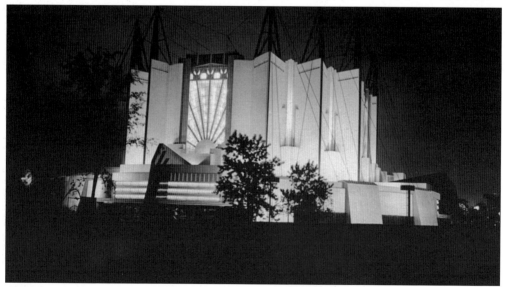

The large window and special lighting on the Travel and Transport Building made it look like the structure was lit from within. The pavilion was somewhat stark during the day, when the cables that suspended the roof drew attention away from the actual building, but at night it took on a new look, both more striking and elegant.

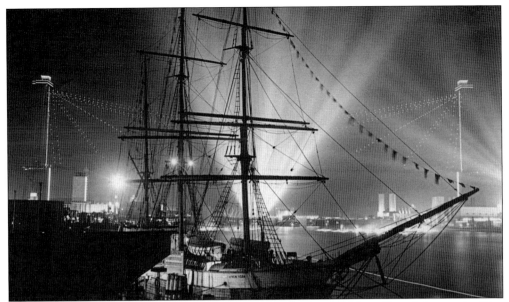

A major effort was made to brighten up the lagoon area for 1934 by adding lights to the Sky-Ride, seen here behind Admiral Byrd's South Pole Ship. After several experiments with new and exotic lighting systems failed, the fair found an easy and inexpensive solution by stringing ordinary 25-watt household bulbs between the towers. Neon lights at the top and new spotlights at ground level helped finish the job.

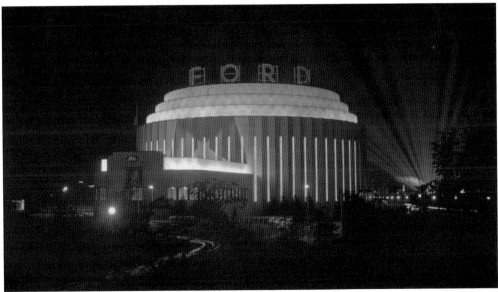

Seen here to the right of the Ford rotunda, the simple but effective lighting on the Sky-Ride could be seen all the way to the southern end of the fair. At times, though, no lighting system could compete with the fogs that rolled in off the lake, causing the towers and other parts of the fair to simply vanish into the mist.

It was perhaps fitting that the Electrical Building was the site of the fair's most impressive lighting display. Seventeen giant searchlights, producing 21 million candlepower of light, shone brilliantly into the sky from towers in the building's courtyard. The powerful beams could be seen for miles around the fair, creating a vivid advertisement for the event.

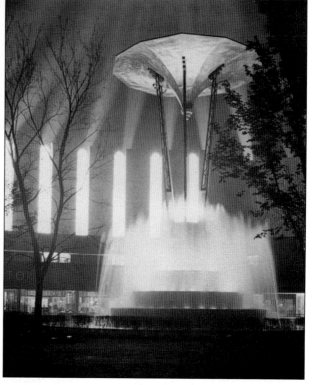

Portions of the spotlights can be seen stabbing into the sky in this closer view of the Electrical Building's courtyard. The central fountain was also quite impressive at night, with its 135 submerged spotlights illuminating the leaping jets of water. The fountain was said to have been especially beautiful when viewed from launches in the lagoon.

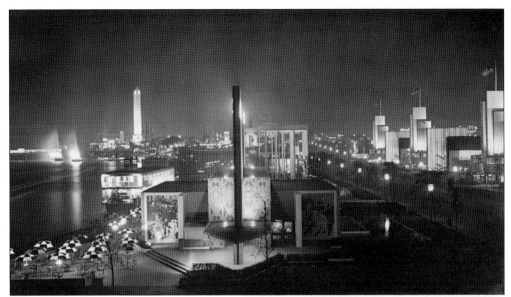

Taken from the Time-Fortune Building, this view of the South Lagoon area captures just some of the magic of the fair at night. Once the sun went down, many of the buildings became much more noticeable. The fair had stringent guidelines for concessionaire lighting and went to great effort to make sure that no one pavilion was too brightly lit so as to detract from those around it.

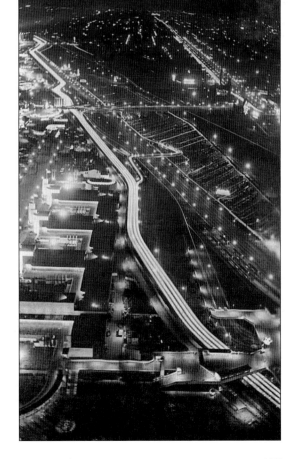

The Sky-Ride provided breathtaking views of the fair and the surrounding city at night. Here, the fair stretches to the south past the 18th Street Entrance, with the General Exhibits Buildings on the left and the main parking lot off to the right. From the number of cars in the lot, it looks like no one went home early that night.

The location of the Havoline Thermometer was picked in part to provide a focal point for the 23rd Street Entrance, which was located near the geographic center of the fair. Undoubtedly, many visitors used it as a beacon to help them find their way home at night. The strange light pattern in the sky is a time-lapse trail of a passing airplane.

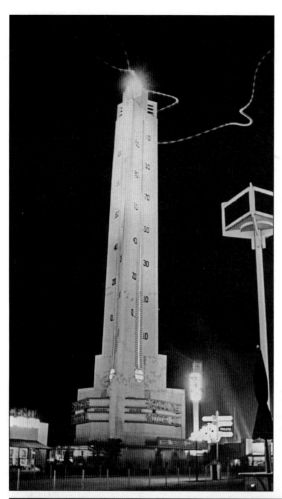

A fireworks show over the North Lagoon was a much anticipated evening event. The shows were held several nights a week and were well received by the crowds, many of whom paid for premium viewing spots in the bleachers on the shore or on the roofs of nearby pavilions. Although expenses were cut for the 1934 season, the fair added additional firework shows in response to popular demand.

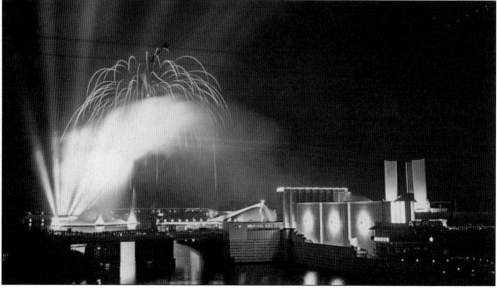

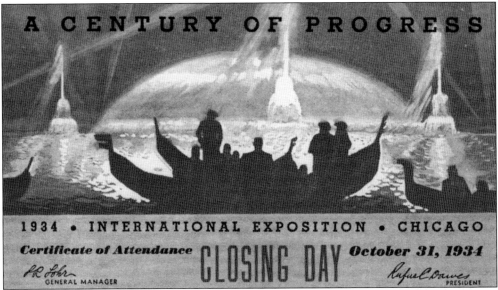

A CENTURY OF PROGRESS

1934 • INTERNATIONAL EXPOSITION • CHICAGO

Certificate of Attendance CLOSING DAY *October 31, 1934*

GENERAL MANAGER PRESIDENT

All good things must come to an end, and the Century of Progress Exposition was no exception. What an end it was! The fair closed on October 31, 1934, which happened to be Halloween night. As the night went on, the record-breaking crowd got out of hand. Looting and fighting were reported across the site. More than 1,000 visitors reported being injured, shops and exhibits were stripped, and thousands of dollars of damage was done to the facilities.

Despite the unfortunate events of the last night, the fair was fondly remembered by the more than 39 million paid visitors over the two seasons. Here, as a bugler plays taps, the flag is lowered at midnight for one final time. Officiating were Rufus C. Dawes, the fair's president (center), and Lenox R. Rohr, the general manager of the exposition (right).

DISCOVER THOUSANDS OF LOCAL HISTORY BOOKS FEATURING MILLIONS OF VINTAGE IMAGES

Arcadia Publishing, the leading local history publisher in the United States, is committed to making history accessible and meaningful through publishing books that celebrate and preserve the heritage of America's people and places.

Find more books like this at
www.arcadiapublishing.com

Search for your hometown history, your old stomping grounds, and even your favorite sports team.

Consistent with our mission to preserve history on a local level, this book was printed in South Carolina on American-made paper and manufactured entirely in the United States. Products carrying the accredited Forest Stewardship Council (FSC) label are printed on 100 percent FSC-certified paper.

MADE IN THE USA